THE COMPLETE GUIDE TO SEXUAL POSITIONS

A SENSUAL GUIDE TO LOVEMAKING

WRITTEN BY

JESSICA STEWART

PHOTOGRAPHED BY
BENJAMIN HOFFMAN

SEXUAL ENRICHMENT SERIEST

Dedicated To Safe, Healthy Sex™

Please Visit Our Website: www.loveandintimacy.com™

Published By: Sexual Enrichment Series^{**} P.O. Box 4326, Chatsworth, CA 91311 USA

Email: info@pac-media.com

Safe Sex Notice: Some of the techniques demonstrated in this publication depict sexual activity that may be unsafe without a condom or an oral (dental) dam if practiced with a partner infected with a sexually transmitted disease (including HIV and AIDS). We support the right of all adults to any consensual sexual activity. However, we urge anyone at the slightest risk to practice the safest sex possible. If you have any questions regarding safe sex, contact your local health department.

Caution: Some of the positions demonstrated require above average physical strength, more than the average man or woman can sustain for the normal length of intercourse. Should any strain occur, contact a medical professional immediately.

Caution: Be careful about the angle of entry for the penis. An awkward thrusting position can be dangerous, as the penis can sustain damage if it is excessively bent.

The authors, photographers, publisher, participants and distributors of this publication disclaim any liability or loss in connection with the instruction and advice expressed herein.

The Complete Guide To Sexual Positions

Copyright © MCMLXXXIII, MCMXC, MMII, MMVII Media Press. No part of this work may be reproduced or used in any form or by any means – graphic, electronic or mechanical, including scanning, photocopying, recording, taping or information storage and retrieval systems – without the express written permission of the publisher. (Formerly Titled: The Complete Manual of Sexual Positions.)

This book is published in the interest of educating adults on the various forms and means of sexual expression. It is not intended to give medical or psychological advice. It is the publisher's belief that every adult has the right to view the material of their choice. Any similarity between persons living or dead, and the events described in this publication, is entirely coincidental. All persons appearing in this publication are professional models, eighteen years of age or older. This product is exempt from the record keeping and labeling requirements of 18 U.S.C., Section 2257. Litho in Hong Kong by Global PSD.

ISBN 0-917181-99-9 UPC 7-41319-12300-3

A 20 19 18 17 16 15 14 13 12 11 10 09 08 07 06 05 04 03 02 01

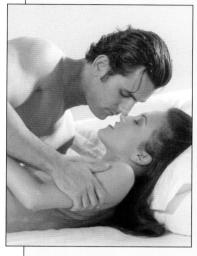

CONTENTS

CREATE A NEW SEXUAL EXPERIENCE

		reface – T	he Lovemaking Repertoire 7
	I	ntroductio	n – A Creative Challenge 8
1	Creative Packaging – Dressing & Undressing for Seduction 11		
2	The Overture – The Orchestration of Foreplay		
3	Erotic Animation – The PC Muscle & Orgasm		
4	The G-Spot Orgasm™ – A Whole Body Experience 26		
5	Voyeur & Lover – Intimate Views of Love		
6	The Intimate Appointment – Vaginal Entry Positions 37		
7	Oral Lovemaking - A Sensual Guide to Oral Sex 85		
8	Anal Lovemaking - The Pleasures of Anal Sex 99		
9	Advanced Studies - The Etiquette of Multiple Partners 107		
10	Positions Index - An Index of All Lovemaking Positions 121		
11	Glossary – A Dictionary of Lovemaking Terms		
ANATOMY DIAGRAMS			
Foot Reflexology Chart 21 G-Spot-Vaginal Entry 27			
Male PC Muscle 24 G-Spot-Anal Entry 27			
Female PC Muscle 24 Female Sexual Anatomy 87			
G-Spot Anatomy 26 Male Sexual Anatomy 87			

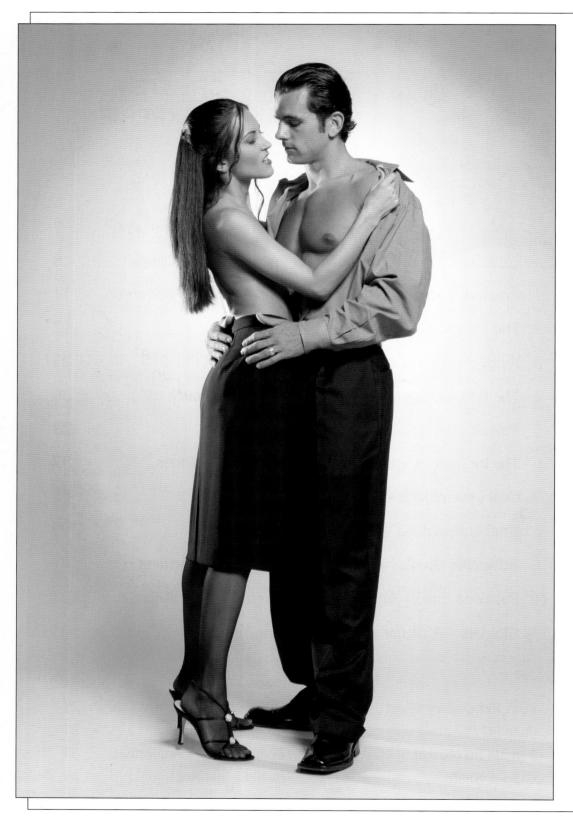

PREFACE

THE LOVEMAKING REPERTOIRE

This manual is both a fantasy guide and a practical collection of examples to help you expand your lovemaking repertoire. I have assembled what my experience has shown me to be the best positions, with useful hints and bits of advice that have come my way over the years – plus some detailed anatomical diagrams to show you exactly what I have in mind when words are inadequate.

You can use this book for its fantasystimulating value alone, but I hope you won't stop there. My sexual advice is too good to go untried, and I can assure you that all my suggestions have been rigorously tested. Some are suitable for a bit of variation on your usual lovemaking; others are best tried when you have a whole morning or evening to experiment with your lover and savor the results.

Of course, I'll be talking about more than just intercourse positions - there are so

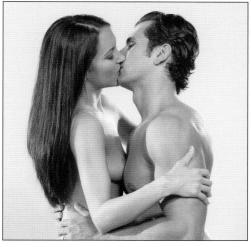

many other opportunities for variations both before and after intercourse (and sometimes, for an exotic change, even in place of it). If you like, you can consider the 'position' of that slinky piece of silk as it's about to fall off your woman's shoulder and reveal a lovely lickable curve of breast; or the 'position' of your tongue on your man's penis that causes a sudden surge through its full length and makes him grip the pillow in helpless anticipation. For me, they're all 'positions' of a sort and all are important, too. As you no doubt know, getting there is at least half the fun, and if I can give you hints on how to make the journey more interesting, with some new side-trips thrown in, then this book will be both a delightful experience and a practical guide for you and your lover. Some of the best seductions are

'some positions are best tried when you have a whole evening to experiment'

spontaneous and unplanned – like a picnic thrown together at the last minute out of what happened to be in the refrigerator at the time. But some of the most dazzling ones are planned, like a gourmet meal – designed, fantasized over, and orchestrated for the fullest range of pleasurable effects. Picnics can happen anytime, but you should try for a gourmet experience once in awhile. The planning is almost as much fun as the banquet itself.

To that end, I'll tell you what's special about each particular position or technique, how to do it, and what you might consider combining it with. I'll discuss everything from A (anal sex) to Z (zippers), and lots in between-like that Grafenberg Spot you've heard so much about (it's worth finding!), unexpected ways to provide oral delights, the etiquette of threesomes, and much more.

Start with your favorite topic or just read straight through. If you're like me, however, you won't get very far before you have an overwhelming urge to practice. Go right ahead. I'll understand.

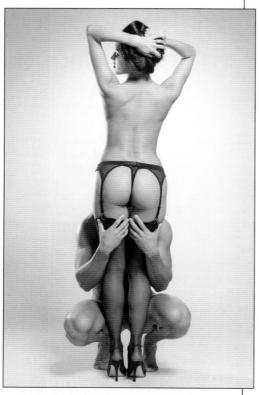

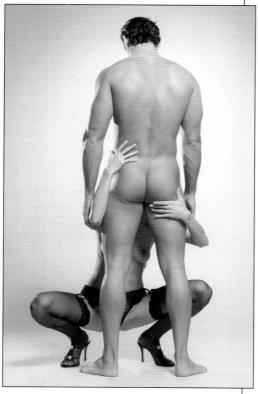

INTRO

A CREATIVE CHALLENGE

love to talk about sex. Often, however, I need to discuss more than just the delicious details and sensations. In fact, a whole range of other personal topics—love, trust, tenderness, jealousy, sharing, selfimage—need to be discussed. I can't describe how a threesome might work, for example, without considering the feelings of the people involved (especially if one feels like the odd lover out), or talk about intercourse as if everyone were always aroused. We're complex, we humans, and any book about human sexuality is going to have to consider a lot before it gets where it's going.

But we don't have to get bogged down in all the intricacies of human relationships in order to learn more about our bodies and share ideas about how to really pleasure ourselves. Remember when you were an adolescent? Remember how you longed simply to know what to do in the back seat? Well, now you know, but chances are you're wondering what everyone else knows, and wishing you could know, too, and enjoy what they're enjoying. You don't need a treatise on love; you'd just like to know some advanced techniques.

Getting these answers is often a challenge requiring some creativity. A bold woman I know once invited a gay male friend to lunch, gave him a few glasses of wine, and then popped the question: "If you had a penis in your mouth, what are some nice things you might do with it?" He almost dropped his glass, but he proceeded to describe to her the exquisite details of what men do to each other's erect penises.

Wouldn't you men like to know just where the Grafenberg Spot is and how to treat it to give your woman a new and spectacular kind of orgasm? Wouldn't you women like to know how to develop your vaginal muscles so as to give your man a unique type of 'deep' massage? How about information on the lovemaking positions that will stimulate your most sensitive spot during intercourse?

We all have lots of reasons to be interested in this kind of information. Our curiosity about lovemaking and our desire to improve are just as 'natural' as the basic sex urge itself. And, furthermore, the more sexual variety you know about and are comfortable practicing, the more you're free to concentrate on the finer points of your relationship. I'm convinced that knowing a few good moves – plus a few 'secrets' about how the other sex sees things – can give you greater confidence and help you come on like the tiger you really are.

As you read the chapters—and I can't emphasize this enough—talk to your partner about what you're reading and feeling. Not only is it a real sign of mutual caring to find out what your lover wants out of sex, it's also fun. You may find that discussing sex and your reactions to it (and having your lover do the same) can be one of your greatest stimulations. More than once, my telling someone how a particular bout of lovemaking affected me has led to another session almost immediately, translating into the physical action that I had just described.

I'll start with a discussion of undressing (for both men and women) and details on all the things you can do before you even think about going further. This is followed by a complete description of the Grafenberg Spot and the pubococcygeal (PC) muscles of the vagina and penis, which will make the next section on intercourse positions more rewarding. And, for greater variety, I follow that with chapters on oral and anal sex (including analingus), and the special pleasures of threesomes, voyeurism, and other unique delights.

Some of this you've no doubt already

tried – you'll recognize those moves and your body will remind you how exciting they are. Others will be new and tempting, and you'll want to try them out at the very next opportunity. And some will be perhaps so different that you may doubt the right occasion to try them will ever occur.

When we do run up against these limits in our sexual experience, it's often because we don't know how to initiate a new type of lovemaking. For example, it takes a particularly bold person to say, "Gee, Cheryl, Barb and I have really been admiring your body tonight! How about joining us in bed?" Yet so

'knowing a few "secrets" about the other sex can give you greater confidence'

many people I talk to wish, with all the fervency of long-held fantasies, that someone would say just that to them someday – or make love to them in front of an open window some sultry night with all the strangers in the neighboring apartment building watching, or burst into the shower one morning and make love up against the tile in clouds of steam, their cries drowned out by running water. It doesn't matter what your favorite fantasy is; with a few hints from this manual, you won't wait for a lover (or lovers) to surprise you – you'll do the surprising!

So don't stop here-turn the page and get ready for some new tricks. Bring your body, your sense of adventure, and your love of carnal delights, and be prepared for a workout!

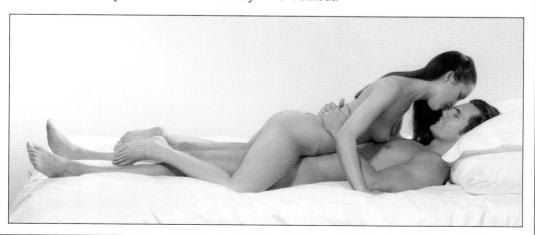

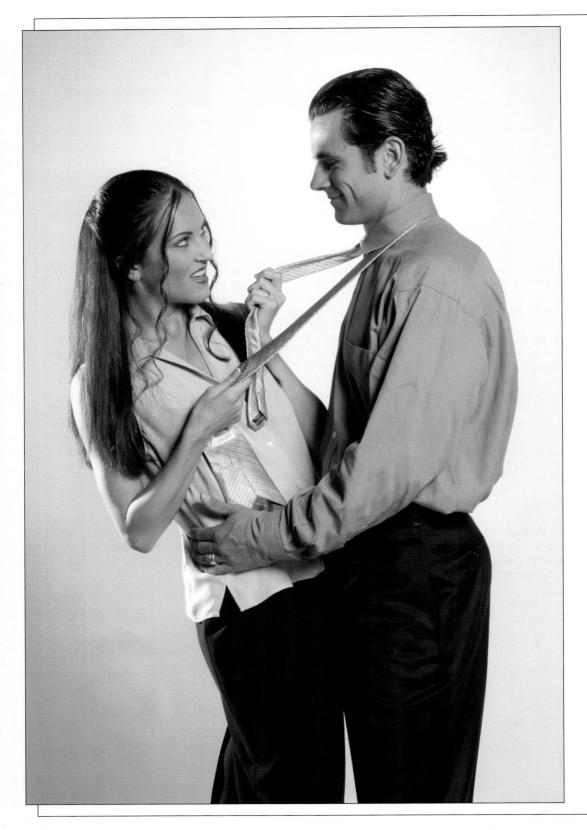

Creative Packaging DRESSING & UNDRESSING FOR SEDUCTION

t's getting to be that time. The candles are burning lower, the wine's nearly gone, and Looth have done their work well. Her lips are parted and slightly swollen from kissing; her eyes are soft and her hair is tousled. You're breathing a little heavier, and something at the front of your pants is straining to get out. The only thing standing in the way of further enjoyment are a few layers of clothing - or are they really 'in the way'?

With a little forethought in your foreplay, negotiating these 'obstacles' can be just as exciting as anything else you do. Forget that utilitarian locker-room strip; tonight you're going to take it slowly and enjoy each piece of skin as it is revealed. I'll start with the woman, but I don't mean to stop there-you men love to be undressed too, and I'll show her just how to do it.

Uncovering Her

After the usual upbringing in our fashionconscious society, a woman is very aware of what she looks like, even without the aid of a mirror. There are few things worse than being expected to be passionate when she knows she looks bad-because her skirt is all bunched up around her hips and makes her look fat, or because her blouse is up around her face while he tries to undo her bra. You know what I mean. Later on, she'll forget her looks when she's close to an orgasm, but especially in those first few moments of seduction, she's anxious both to look and feel beautiful.

So gentlemen, please help her. Your thoughtfulness can only help you.

To begin with, whenever possible, start from the top and move downward. Unbutton her blouse from the top, exposing little by little that deliciously sensitive area above the breasts. When you've got enough of the blouse open, push it back off her shoulders a little and admire the curve of her neck. And don't just admire; use your hands, your lips, and even your hair to let her know how sensuous this part of her body is.

And once you've opened her blouse past her breasts, linger a little and play with them through the cloth. If she's wearing a silky-type fabric, the feel of your fingernails scratching lightly across the nipples through the material will be unendurable-and if you're lucky enough to have a braless woman, you'll have trouble keeping her from ripping her own

blouse off at this point.

But a bra can be a sexy toy in its own right. Those straps, for example. Without them, a woman feels very vulnerable; so gently push them off her shoulders and kiss the spots where they were. And wait before

> 'forget that locker room strip - tonight you're going to take it slowly'

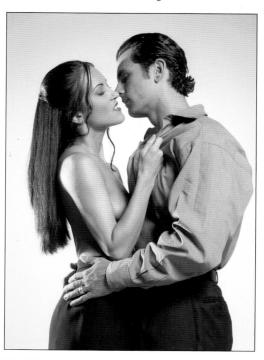

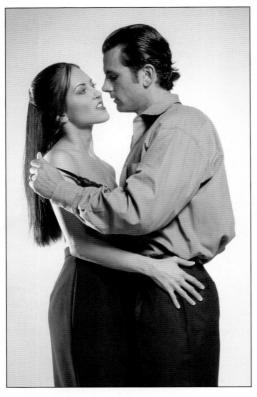

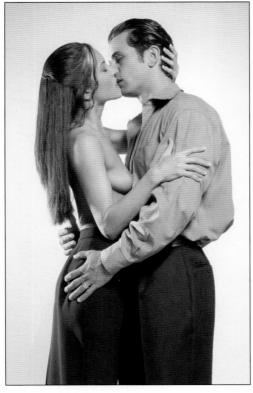

reaching around to fumble with the hooks at the back – first peel the cups down, nuzzling her flesh as you go. Her arms are immobile because the straps are still around them, but that's fine; she's helpless with delight anyway. And if she's got a secret longing for a little submission, so much the better!

'unbutton her blouse from the top, exposing the flesh above the breasts'

The moment when you expose her nipples is an important one. If she hasn't done so already, she's about to abandon herself to your caresses—so go slowly. Pause just before you get to the areola, maybe even back up a little; she may be so alarmed that she will be inspired to say something quite indecent to get you to go on.

Once the nipple is exposed, and you've lavished attention on its sensitive circle (see Chapter 2 for some new ideas), you can slide the bra down to the midriff. This exposes the whole bosom and makes the bra looser, so it's easier to remove.

Off With Her Bra

Men sweat more over this step than almost any other-just look at all the jokes in the movies about removing bras. But it's really not that hard; women do it every day.

Brassieres seem complicated, but there are basically only two types: those that hook in the back and those that hook in the front. If you're really experienced with the first type, you can reach around and unleash your lady with one hand by squeezing the clasp. It's very simple: put your thumb over the end of the bra with the hooks on it (the end that laps over) and your first finger (or first and second together) on the other end, and push the fingers toward each other. When you release pressure, the hooks should be free and the whole bra will part. If it doesn't work the first time, just do it again more firmly; women sometimes have to try a few times, too.

If you don't feel so confident, you have two options. First, you can twist the bra around so that the clasp is in front (keeping your partner's breasts entertained all the while) and unfasten it there, where you can see what you're doing. Or, you can turn your woman around and unhook her from the back. This latter doesn't need to be just a practical operation; think of it as a variation on the old "darling, can you undo my zipper for me?" routine, and do it slowly and sensually. Her position at this point, with her back to you and her head down, is not an ungraceful or unpromising one. You can use this moment to cup her breasts from behind as they become free, and to make love to her neck and back.

Bras that unhook in the front are a lot of fun for both the woman and the man. Because of the hook placement, they're easy to undo – sometimes too easy (from her point of view), as an enthusiastic hug can spring her loose when she's least expecting it. But it enables you to expose her breasts without any acrobatics – often simply by cupping her breasts from the sides and squeezing them together, then releasing. Her breasts then are all yours to lick and nibble as you push the cups away to the sides.

If your woman's breasts are as sensitive as mine, you may both be plenty excited just by this operation and its consequences. But at some point-for practicality, if nothing else-you will need to think about getting her skirt or pants off.

Onward & Downward

With a skirt, you can start from the top or the bottom. Moving a hand slowly up a woman's skirt can be powerfully erotic for both of you, but it doesn't really work unless her skirt is wide enough for you to play around inside it. If it's narrow, do a number with the zipper instead, and peel her lovingly from the top down; the same with slacks or jeans. When the moment comes to remove her underwear, pull it down off her bottom ever so slowly, exploiting that sudden rush of vulnerability, tonguing the crease and stroking her cheeks.

The same principles apply to all other articles of clothing-pantyhose, socks, slips, whatever. Go slowly, avoid making her look awkward (don't pull her legs up in the air to take off her pantyhose, for example; coax them down while she's on her back or even standing up), and show your appreciation of each new area of skin as you gain access.

Uncovering Him

Granted, when people think of strip acts, they don't usually think of men first; but

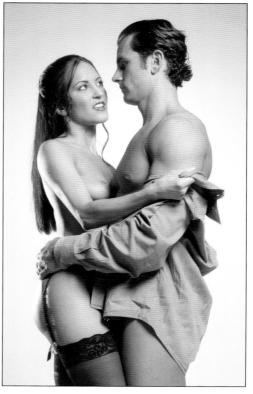

you'd be surprised how many men have told me, "I really like being undressed." And women who know how it makes them feel

are only too happy to oblige.

Many of the same principles apply to men and women when it comes to undressing. Find the parts of your lover's body that are most sensitive, and that he is most proud of, and expose them slowly and with appreciation. Does he like how his biceps look? Then make a big deal out of pulling the shirt down over his upper arms. If he has a great chest, linger over the unbuttoning and over the curves of his chest muscles. And, if the muscular areas around his nipples are sensitive, then undress them the way you'd like your own breasts to be undressed. Many men get very aroused by having their backs caressed: in this case, take off his shirt from the back, nuzzling the back of his neck and continuing down his spine with your lips, your teeth (gently, of course), and your tongue. And, if he likes the feeling of being stripped and being made love to from behind because it has a touch of submission to it-well, you know what to do with that.

In general, men can tolerate a little more roughness than women can, so take advantage – dig your nails in just a bit as you draw the shirt down over his arms, and take a little nip at the hollow between his neck and shoulder as it's exposed. You're doing the stripping, after all, and it never hurts to let him know who's in charge at this moment.

Down With His Pants

Understandably, men are very excited about the moment when their crotches are exposed. But, again, treat this moment with the same kind of slow savoring that you enjoy—caress him **through** the cloth before you even begin playing with the zipper. Try a trick that my man loves: bend down until your mouth is close to his penis, open your mouth and take a deep breath, press your open lips against him, and blow all that warm air against his penis. It will take a second or two to penetrate, but you'll know when he feels the sudden warmth; hold him down just in case. It's a different sort of 'blow' job—try it, I'm sure he'll like it.

And if you're still feeling a little dominating, take the opportunity to play with his belt as you undo it, especially if it's leather. Do more than just unbuckle it—whisk it off through the belt-loops (always a startling

move). Hold it taut at both ends and look aggressively into his eyes. Place it across his chest and hold him down on the bed with it. If he responds to that, try slapping him a little around the midriff with it, but don't go too far with this game.

When I pull my lover's zipper down, I like him on his back, with me straddling his thighs. Not only can I keep him immobile while I take my pleasure, but he gets quite a show as his penis is finally let loose from the imprisonment of his pants and underwear. Imagine his visual stimulation with an excited woman sitting over him, her breasts in full view, swaying slightly with the effort of her movement. He gets to watch her as she concentrates on that most glorious sight—an erect penis emerging, strong and hard and ready for action.

Now's the time, ladies. Now you speed up, wrestle his pants to the floor and pounce!

More Than Nakedness

Being totally nude is certainly the most comfortable and practical way to make love, and now we've talked about how to get that way with a great deal of pleasure. However, don't discount the sexual power of a little clothing, not just for seduction, but to be kept on during the entire lovemaking session.

If this is a new idea that makes you a little self-conscious, don't worry. A little black lace or leather won't make you a strip queen or a sadist, but it will have remarkable effects

on you and your partner.

You men, now: next time, try wearing just a vest. It doesn't matter what kind – business wool, cuddly corduroy, or cowboy leather – just an unbuttoned vest next to your bare chest. It makes almost all men look great – accentuates the broadness of their shoulders, exposes those upper arms, and leaves a nice slice of their chests exposed, much like a shirt open to the waist. And, because the vest is open, the woman has access to all of the man's torso.

Or, wear a hat. They have definite personalities and can be very thrilling to a woman. Let your imagination and your sense of theater guide you here. A Greek fisherman's cap? A cowboy hat? A sinister gray fedora? A pimpish wide-brimmed Panama? Feel free to act out your fantasy a little. If you feel like being a pimp tonight, try it out, and see if she likes being a whore for you, just in play. Tell her how much she's

worth, that she's the best in your stable of hookers, that her body is famous among the sensual connoisseurs of your town – or whatever else strikes your fancy. Her responses may surprise you!

For you women: your choices are many. Try a lot of heavy jewelry, for example: dangly earrings, heavy pendants or noisy bracelets. Dazzle him with shine and move-

'you'd be surprised how many men like to be undressed'

ment against your bare skin – play Cleopatra or a vamp. The jewelry doesn't have to be expensive or exotic; those wide bangles look harmless enough around the wrist, but push them to the upper arm and they become slave bracelets.

As a variation on the jewelry idea, try a demure Victorian black ribbon choker or a delicate leather strap around your neck. You'd be surprised how the most ordinary, respectable streetwear can take on a sexual allure that's almost unbearable if it's worn in bed with nothing else to distract from its effect.

Those black lace teddies are another example. They're pretty enough under a sheer blouse, or as fancy underwear for a formal occasion, but seen alone in a candlelit bedroom they're dynamite. Not only are they

skimpy and lacy, but the straps fall down at the least provocation, and the crotch usually unsnaps so you can keep them on during intercourse. Greet your man in the bedroom some night with your teddy open at the bottom, or, better yet, let him undo you after you've gotten all wet and eager – and reap the rewards of creative packaging.

Or, wear an open robe, or kimono, as you lie on your back, leaving the front partially covering your breasts, so he gets that most erotic of sights: an erect nipple thrusting through thin material. You'll be totally accessible to him, but you'll look like a silky package half unwrapped, and the idea of opening you, and savoring the contents, will spur him to more impressive efforts.

And remember that standard male fantasy of a woman coming to the door clad only in a towel? Come after him sometime when you've just gotten out of the shower, or the pool, and wear nothing but a towel. No matter how tightly it's tucked in, it always seems to come loose, but you can use it even then to create a love-tent, or form a cushion for you, if you end up making love on the bare floor (you may not have time to get back to the bed!).

Use your creativity in all aspects of undressing. Whether clothing is coming off, or staying on, the fantasy associations are strong and erotic, and you'll be able to intensify your own, and your lover's, sensations by careful attention to timing and technique.

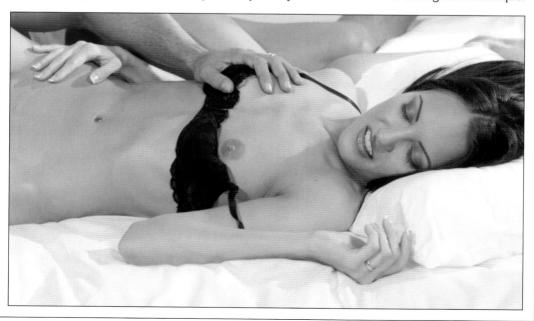

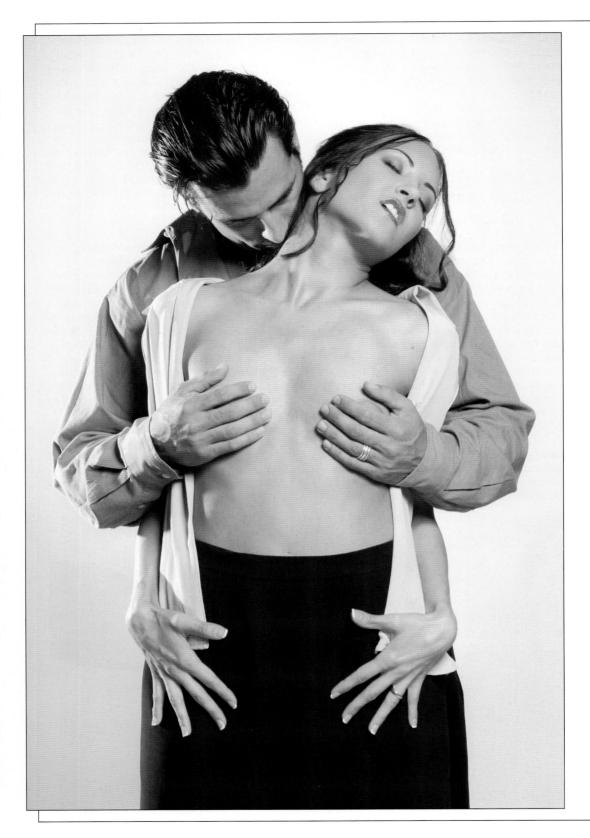

The Overture

THE ORCHESTRATION OF FOREPLAY

hen exactly does foreplay begin and end? That's hard to say. Maybe it begins when that 'friendly' massage of his dips farther forward on her shoulders than friendly massages usually do – and when she doesn't stop him. Or, maybe it began hours before, when he began to fantasize about sliding his hands down toward her waiting breasts. Maybe it begins during an ordinary kiss when she suddenly forces her tongue between his lips, just when he's least expecting it. One thing is for sure: it doesn't necessarily end when the two of you get between the sheets or when the penis enters the vagina. Good foreplay is great anytime.

But building sexual suspense is a particular sort of game and one that benefits greatly from a little planning ahead of time. It deserves its own special place in your sexual experimentation—and its own chapter.

Sneaking Up

As with premature undressing, premature stimulation is often a real bore. So you can kiss your lover all over in five minutes and cover every sensitive spot—so what? As I have said before, getting there is more than half the fun, and unless you're really strapped for time, you owe it to yourselves to take the time to create some great sexual suspense.

And it's not just men who are eager to jump the gun. Women often think they've 'run out of things to do' and clasp their hands over a man's penis, escalating the whole situation to the point where it will inevitably be over in a few minutes—and then they wonder why they're so disappointed.

Anticipation and surprise are the key ele-

ments in foreplay. For instance, with both sexes, kiss around the mouth lightly before you even get to the lips; your lover will be seeking your lips avidly by the time you're ready to go mouth-to-mouth. And, once you're kissing, use your tongue like a plaything instead of a plunger; flick around the edge of the mouth, dart under the edge of the lip, slowly working your way in, taking turns probing and being probed.

'sexual suspense benefits greatly from a little planning ahead of time'

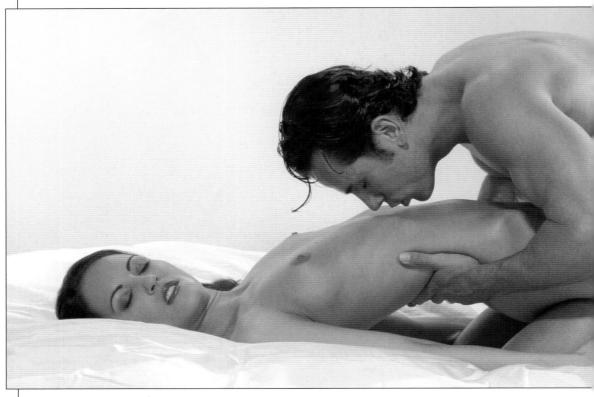

Kiss unexpected places: the tops of closed eyelids, temples, the tip of the chin, under the eyes. Kiss in unexpected ways: dry, then suddenly wet, or cool and brushing, then hard with a little nip thrown in. With this kind of care and attention toward detail, your lover will never get bored.

As you proceed toward the classically sensitive areas, follow the principles in Chapter 1 ('Creative Packaging'): sneak up, go slow, let the anticipation do its work. Your partner will be excited far out of proportion to the actual physical contact you've had up to that point.

Think carefully, gentlemen, about those lovely, soft breasts you've just uncovered. Now that you've actually got them exposed, resist the urge to gobble; start toward the edges of the breasts, stroking, kissing, licking, nibbling. Go all the way down the line of cleavage this way as if you were never going to get to the nipples. She'll be aching for your touch by this point, so don't tease her too much longer. Work your way in slowly, in big circles, watching her face as she begins to breathe more heavily, to shut her eyes, to arch her neck as she concentrates more on her sensations.

'anticipation and surprise are the key elements in foreplay'

Tantalize her nipple. Brush across it with your hands, your lips, your hair, go away again, come back with a little more pressure. Concentrate on her reactions to be sure you're not increasing the pressure too quickly; most women's nipples are extremely sensitive, and there is a limit to what she can take before the sensation stops being sexual, and becomes irritating, painful, or numbing. If her excitement doesn't seem to be building, move to some other spot and come back later. Keep in mind, however, that some women can take (and desire) more and more pressure as they become increasingly aroused. Even light biting is sometimes appropriate. After all I've said about gentleness, you might feel like a barbarian, but it may be just what she likes.

And women, remember that it's a long way down to his penis-there's all that skin to make love to before you're even close.

Travel down his torso with your hands and mouth, tasting and touching along the way; his penis will know you're coming and often wave to you to hurry up. (Ignore it; what's your rush?) Sweep your hair across his chest and listen to him sigh.

When you get close, kiss all the way around his pubic hair. Take a detour down to his knees and come back up the inside of his thighs. When you do arrive at his penis, consider your moves carefully. If this is just foreplay, you don't want him to ejaculate yet, so stay in control; confine yourself to exhaling lightly, and warmly, down the length of the penis, or brushing it with your hair, or stroking it gently with your fingers. He won't think he can stand it, but he can. And if he climaxes... it's okay. You've got many more lovemaking sessions ahead of you.

The Play of Foreplay

Many people find that it's easier to play before intercourse starts; somehow the atmosphere gets more serious then (although there's no reason it should), and they fear it's inappropriate at that point. Be that as it may, your own seduction scene is the perfect place to act out some fantasies.

Remember the pimp-and-whore fantasy in the last chapter? Try some others. Maybe she's a virgin again and he's an experienced, suave, older lover; she pretends to be timid and passive and he takes over, murmuring sweet French nothings, bending her over backward for long kisses (don't laugh—it's great!), telling her in advance what he's going to do to her and how she's going to feel. Or, perhaps the roles are reversed and she's the older woman initiating an eager but inexperienced young man, stripping for him voluptuously and teaching him what he needs to know.

Or, maybe you're both animals—lions, for example—circling each other, sniffing and growling, coming stealthily closer until you suddenly connect in a swirl of fur and claws. When you trust your lover and are really aroused, nothing is too silly. If you don't believe me, try growling softly at your partner as you nuzzle his or her ear, and see if you don't get a sexy feline snarl in response.

And because your fantasies are just fantasies, you can take other risks, too. You women can make him promise to sit or lie absolutely still while you tease him into a frenzy of desire – and this scenario doesn't

detract from his masculinity or make you look like a dominatrix. If she's feeling a little wild, men, you can pretend to struggle and subdue her; that doesn't mean that you're being too aggressive. As long as you know and trust each other, all the roles you've ever wanted to play become possible.

Tantalize, Tantalize

Here's a list of suggestions for some subtle, but effective ways to escalate passion. Use them alone or in combination with your usual foreplay, and watch the temperature go up.

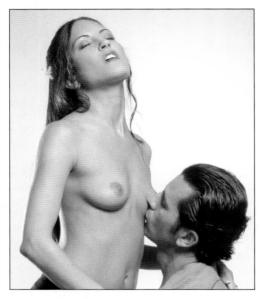

Giving Good Palm

I once nearly melted when a soon-to-be lover tried this one on me: he took my hand as if about to kiss it on the back in the normal way, then suddenly turned it over and buried his mouth in the palm, giving me a long, wet, rich kiss with lots of tonguestroking. I really don't know why it was so effective – maybe the combination of a chivalrous gesture with earthy passion – but I've used it to good effect myself since; it works on men, too.

Fellating Fingers

When is a finger not a finger? When you treat it like a penis! Stroking your man's finger up and down when you're in public and can't get at the real thing is an old trick, but have you ever tried going down on a finger? Sounds silly, but it's surprisingly enticing,

and you can be bolder than you would be with a penis. Suck really hard on it, for example, and dig your teeth into the tip. And he's got ten fingers. Strange to say, I love having it done to me, so it can't be just the anatomical analogy that makes it so stimulating.

Foot Fondling

Providing feet are clean, they can be very sexy. The line between tickling and sexual stimulation is often a fine one, and what more ticklish place is there than the soles of

'concentrate on your partner's reactions to guide your intimacies'

the feet? Try sucking the toes and licking the spaces between them, or nibble on the meatier parts of the foot; your partner's toes will curl in anticipation. And then lick the soles of your lover's feet until your tongue becomes a little dry and rough. When you draw your tongue over the sensitive arch, it will feel like a very amorous cat at work.

A foot massage is soothing, but it can often be more than just that. Look at the chart on page 21, and notice how many parts of the body can be stimulated by skillful manipulation and probing of the foot. Caressing the foot can turn into a surprisingly erotic experience for both of you.

The Other Head

The one with hair on it, I mean. For being just a bunch of dead cells, hair certainly can pack a lively sexual wallop—and for both parties, too. I love having my hair brushed and fondled by a man. It relaxes me and gets me used to his caresses again if we haven't made love for a while. But if he blows in my ear gently, or kisses my neck while he's doing it, I don't stay relaxed very long!

And what can I do for him? He may not have very long hair for me to play with, but I can certainly use my hair to arouse him. Here's a trick for you longer-haired women to use when you want to build his excitement: trail your hair down his chest, as I've described earlier, and stop when you get to his penis. Now swirl your hair around it several times until a lock catches on itself—then

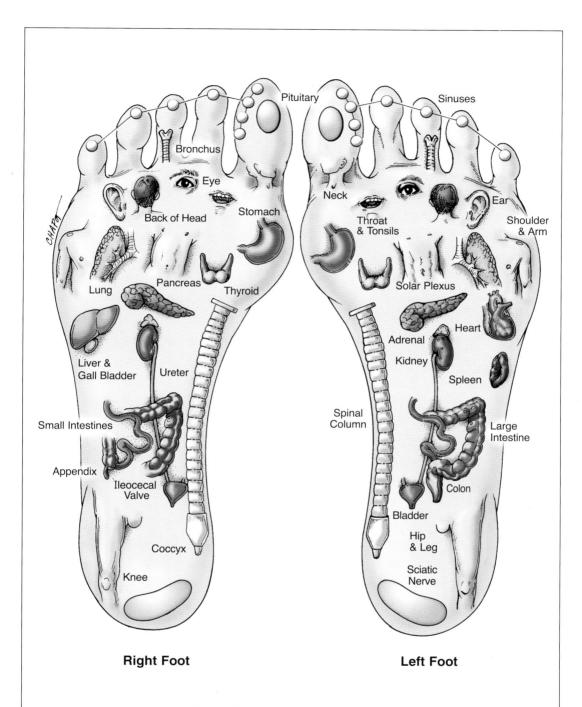

Foot Reflexology Chart

A foot caress using reflexology is a wonderful way to seduce and relax a lover. As can be seen in the above chart, the nerves for most of the body parts end in the feet and are easily accessible for manipulation. Lightly massage the soles of the feet with the pads of your fingers. Should you get a response of soreness from your partner in any particular part of the foot, it is an indication that there is stress in the body part mapped in the chart. Continue to massage gently, and firmly, until your partner experiences some relief.

'there's lots of skin to make love to before you get to the penis'

pull slightly, creating a vise with your hair. Release when he stops moaning, uncurl your hair, then start again. You can keep your man going a long time with this one. The pressure is never quite enough to bring him to the edge, and the lightness and coolness of your hair sliding across his skin is excruciatingly pleasant.

Then there's the pubic hair, of course. Brush your hand across it or pull on it gently—the nerves at the base of the hairs will send your message where you want it to go.

Heavy Breathing

We usually think of sex as being hot or at least warm, but the sudden contrast of a cold stimulus can often heighten passion, as well. I'm not advocating an icepack on the testicles or anything so drastic-just your breath on wet skin. It's a startling, and exciting sensation, and can be performed by either partner anywhere on the body, but try in particular the breasts, the penis, and the ears. After you've been kissing and licking for a while, the sensation begins to diminish a little; dry your lover with your breath, and you can start afresh with your tongue.

Scouting For A Location

Intercourse and orgasm often require some forethought as to physical surroundings; some positions require a horizontal surface such as a bed, for example, and privacy is more important. Foreplay, happily, has fewer such restrictions. You can start right where you are, whether it's at the dinner table, at the kitchen counter, in the park (be careful, though!), at the movies, or on your couch. You don't need soft cushions, dim lights, or any other particular setting to begin your sexual adventure; you can even stand up the whole time, except that your knees will probably go weak.

One of the nicest surprises is having an ordinary experience unexpectedly turn into a sexual one, like the 'friendly' massage I mentioned earlier. Next time your man is at the sink, chopping vegetables or washing dishes, give him a hug from behind, then get bolder with your hands on his front while you kiss his back, neck, or any other part of his body you can get to. Make sure he doesn't have a sharp knife, or your favorite crystal in his hand, when you both get wild, however.

Or, do the same to your woman when she's sitting reading at a desk or table; lean over her from the back, kissing her hair, and slide your hands slowly under her blouse. She'll probably lose her place, but she can always find it again later.

Often it's the routine interruptions that make foreplay seem ordinary: closing the shades, turning down the lights, locking the doors, preparing the bed. During that period you can lose your enthusiasm, or even have second thoughts about the whole enterprise. Whenever possible, avoid such interruptions. Seduce your lover wherever you are, (with reasonable concern for the law and for other people's sensitivities), without fussing over your circumstances.

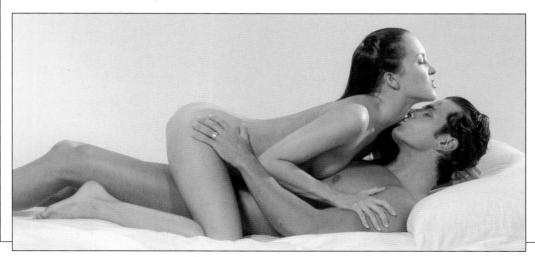

Erotic Animation THE PC MUSCLE & ORGASM

any men think of the vagina as a smooth, soft sheath – something they open up and probe with their penises. And it often can be. But imagine their surprise when they find that the vagina has its own physical powers – that it can squeeze and undulate, draw them in and even push them out. Likewise, women often think that the penis is capable of only one movement – in and out. They're equally surprised when they feel pressure on the front surface of the vagina, and a sensation of expansion, and realize (with a smile and a sigh) that the penis has the capacity not only to move up and down, but also to swell and pulse.

The key to this erotic animation is the pubococcygeal muscle (called the PC muscle) found in the pelvic region of both men and women. We've always had this muscle, but a lot of people did not know they had it (or how to use and develop it) until recently. You may find that you've been using (and enjoying) it all along – you just didn't know what to call it. Or, you may be a newcomer to this important sexual function.

The Importance of Good Tone

We often think of sex as such a 'natural' activity that the idea of consciously developing a muscle just to copulate may seem strange. Lovemaking wouldn't seem to require anything but a good attitude, a willing partner and some relaxation to work well. And often this is true. But you're already using the muscles of your thighs and pelvis, even without thinking about it, to guide your intercourse and give you the proper angle of insertion. Learning where the PC muscle is, and how to use it, is really not difficult. And knowing its 'tricks' is like riding a bicycle – once you've mastered it and enjoyed the results, you'll **never** forget how!

What are the benefits of manipulating your PC muscle? Consider this, ladies: without saying a word, you will have a lot more to 'say' about how his penis makes contact with the inner walls of your vagina—specifically, you'll be able to bring it closer to the Grafenberg Spot (see more on this in Chapter 4), which can make intercourse into a wonderfully different kind of experience. Research indicates that good PC muscle tone promotes increased lubrication, stronger clitoral sensations and often multiple orgasms. Some women can even achieve an orgasm by simply contracting the muscle alone.

This would be wonderful by itself, but there's more – what makes **you** happy makes him happy, too. It's a fact! Your live, animate, moving vagina, pleasuring itself, gives your man pleasure, as well. You can contract it around his penis continuously, just on the in- or the out-stroke, or in any rhythm that suits you. He'll think you have the tightest vagina in the world. And if you can keep up the muscle tension during orgasm, you can give him the often unbearably pleasurable sensation of being 'milked' by your pulsing vagina.

As for you, men, that sudden surging in your penis when you use your PC muscle will make your lover's vagina feel even tighter to you, and the added friction will intensify the sensations as you slide back and forth inside of her.

The Location

It's hard to describe just where the PC muscle is, other than to say that it forms a 'figure 8', looping around and supporting the pelvic organs, about an inch inside the surface. It's much easier to find it by exploring what it does.

Imagine yourself using the bathroom. Suddenly the phone rings. How do you stop the flow so you can get up and answer the phone? You contract the PC muscle. You see, it's not a muscle just for sexual purposes—you've been using it all along for other reasons. It's only a matter of gaining better control over it and toning it a little to enhance its function in lovemaking.

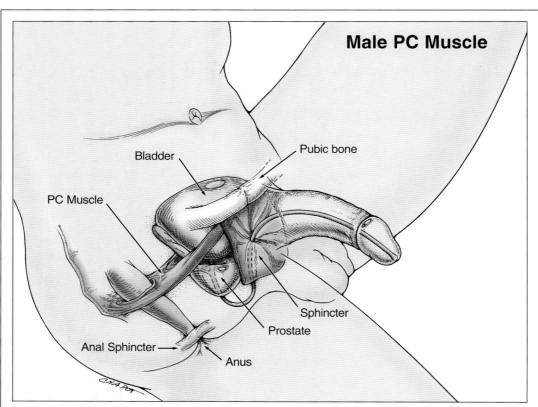

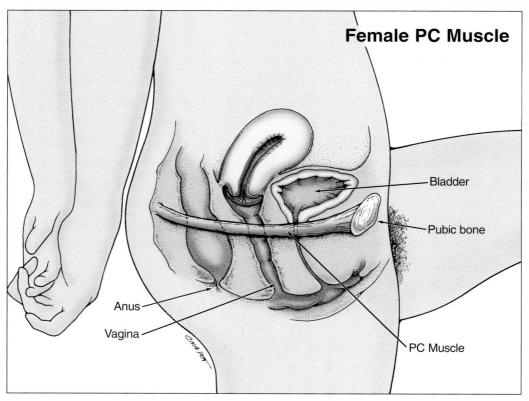

'good PC muscle tone promotes stronger clitoral sensations and often multiple orgasms'

Developing The Female PC Muscle

Now that you know where it is, and how it feels to use it, ladies, exercise it! Right now, while you're sitting and reading, tighten the PC muscle for a second (without moving anything else), and then release it. To be sure that you're moving the PC muscle and nothing else, move your legs apart just a little.

For a week, exercise your PC muscle six times a day, tightening it for a few seconds ten times during each session. You can help yourself remember to do it by getting in the habit of exercising every time you use the bathroom, or get into the car, or pick up the phone. The second week, move up to 20 contractions per session and try a new exercise in addition: instead of holding the muscle contracted, tense and then release it quickly, ten times, creating a 'fluttering' sensation. Your muscle will tire at first like any other, but by steadily increasing the number of exercises (and being careful to relax completely in between contractions—too much muscle tension is just as bad as not enough), you can build up your strength and control. When you reach 50 contractions and flutters per session, you'll be ready for the big time; you can be your own vibrator this way.

Now Experiment

A variety of pleasurable effects can be created by well-timed use of your PC muscle. Squeeze on the in-stroke, and it's harder for him to enter – he can indulge his fantasy of deflowering you again. This also stretches the penile skin back from the top, which heightens his sensation considerably. Squeeze on the out-stroke, and you can keep him inside a moment longer, tightening just a little extra as the head gets close to the opening, and putting pressure on that sensitive area right at the edge of the vagina. Or, squeeze according to some exotic rhythm known only to yourself – one that matches the rhythm of his penis when he climaxes, or that echoes the beating of your own heart. Your vagina has a personality of its own – express it!

Some women report that they can alternately tense the urethral and anal sphincters to create a rolling or rippling effect. Just be careful and know your own strength. After you get quite strong, you may suddenly squeeze him out when you don't intend to, especially after he's acheived orgasm.

Developing The Male PC Muscle

Your exercises are different, guys, but just as pleasant as the women's. You need to practice contracting as well, but try this trick to show yourself how well you're doing. Find a time when you're alone and stroke yourself to an erection. Stand up and drape a handkerchief or a light towel over your penis (I'm not kidding!). Now contract your PC muscle rhythmically (remember it's the muscle used to stop the flow of urine), and try to make the cloth move up and down. Increase the number of times you contract, as I explained for the women. As you get used to the sensation of using your PC muscle, you won't need the cloth anymore; in fact, you'll be able to develop your muscle wherever you are without anybody knowing what you're doing.

Luscious Experimentation

Next time you're having intercourse with your partner, men, give her a treat: stop thrusting for a bit and just squeeze the PC muscle rhythmically. You'll feel that intense tightness – but without the direct friction that might make you ejaculate sooner than you want to. She'll love the feeling of your penis stretching and filling her, and you may be better able to put pressure on her Grafenberg Spot, which can lead to different and often incredible orgasms for her (see Chapter 4 for more on the Grafenberg Spot). Some men say that developing greater control of their PC muscle gives them more intense orgasmic contractions. Match her beat, or counter it with your own; your penis is a lively, mobile beast, and she'll respond to it with delight!

The G-Spot Orgasm A WHOLE BODY EXPERIENCE

was a skeptic, but now I'm a believer. The Grafenberg Spot is real, and it not only explains intense sensations that women have been trying to express for years, it also helps other women to experience totally new types of orgasms. With stimulation of the Grafenberg Spot, women have orgasms that are by all accounts *different* from those produced by clitoral stimulation alone; orgasms that feel deeper, last longer, and are often more satisfying.

Forget the controversy about clitoral versus vaginal orgasms. Research on the Grafenberg Spot indicates that women are capable of a whole continuum of sexual responses involving

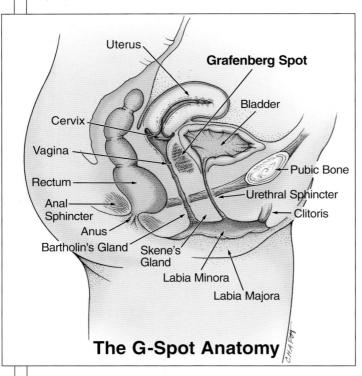

both clitoral *and* vaginal stimulation. Ladies, if you've never had an orgasm from vaginal stimulation alone, finding and stimulating your Grafenberg Spot will open up a whole new experience for you. And if you've always had a 'special spot' in your vagina that you've tried to hit during intercourse, you'll be able to pinpoint it more precisely. As with so many things, knowing what you're doing gives you control over its function.

Finding The Spot

It took me quite a while to find my Grafenberg Spot – and I know my body pretty well. So be patient with yourself, take the time to get to know your vagina, and note these suggestions: For your first explorations, sit down or get on your hands and knees. It will be easier to feel the spot if you are aroused, so take this as an

opportunity for some self-pleasuring before you start. You'll be more acutely tuned in to sexual sensations, and you'll know more clearly when you've hit the Grafenberg Spot.

When you're aroused (or even after you've already reached orgasm), put a finger in the vagina-your middle finger, as it's the longest-and locate your reference points on the upper (forward) surface of the vaginal wall (**see diagram**): first the lumpy Skene's gland just inside the opening, then the hard area that you can feel through the skin (that's the corner of the pubic bone), then a smooth area leading back to the cervix (which you may or may not be able to reach, depending on the length of your finger). Come back to the pubic bone with your finger and hook the finger in back of it, finding a little hollow just before the smooth area begins. Your finger will be pointing up toward your navel at this point, not back toward the cervix or the anus.

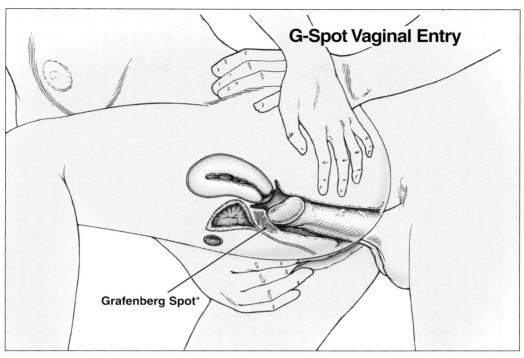

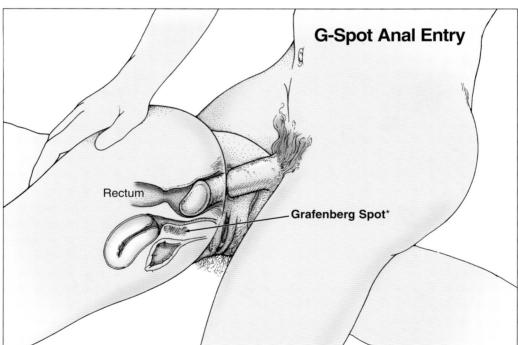

Probe this region firmly with your finger, and when you hit the Grafenberg Spot, you'll feel a jolt and a momentary urge to urinate. If that feeling alarms you, you may want to stop at this point – but don't. Many women miss some extra sensual pleasure because the association between sexual

*Note: Please do not feel that there is a precise 'spot' that must be touched. The surrounding area is also very sensitive.

arousal and possible urinary incontinence makes them uneasy. Empty your bladder, if the feeling is overwhelming, and try again. Now there's nothing whatsoever to worry about, and you can continue to stroke the Grafenberg Spot (which in many cases will swell and harden until it feels like a small bean under the surface of the skin) until the urgency to urinate passes and turns into a warm, deep, sensual feeling that is distinctly different from clitoral stimulation. You can sometimes intensify the feeling by pushing on the corresponding area of the lower abdomen while stimulating the spot from inside.

When women try to describe the difference between orgasms that focus on direct clitoral stimulation and those that involve manipulation of the Grafenberg Spot, they say that clitoral orgasms feel sudden, sharp and explosive, and that the sensation is limited to the pelvic area and very narrowly focused. Grafenberg Orgasms feel deeper, slower, more relaxed, and affect their whole bodies in a warm wavelike spread of sensation.

In practice, of course, both the clitoris and the Grafenberg Spot often get stimulated, either together or one at a time, and the sensations get mixed up. Probably the majority of women's orgasms are mixtures of the two kinds of stimulation, but recognizing what separate Grafenberg stimulation feels like can help you to widen your range of sexual feeling and have a better understanding of your body.

Intercourse & The Grafenberg Spot

It's easiest to find the Grafenberg Spot with your (or your lover's) finger, but it's also quite accessible to the penis – in fact, some of the most satisfying mutual lovemaking takes place when a man strokes the Grafenberg Spot with his penis, giving both of you intense simultaneous stimulation.

I've found that the best way to stimulate the area is to use rear-entry positions. The slight upward tilt of his penis as he slides into the vagina means that he comes into direct contact with the Grafenberg Spot nearly every time he thrusts, and the result is nothing short of sensational!

And men, take note: with increased control of your PC muscle, you'll be able to tip the penis up even more, enabling you to aim for that little hollow and drive your woman wild. Many women also like the woman-on-top positions because they can control the angle of the penis and make sure it connects with the Grafenberg Spot. (See Chapter 6 for more variations on this.)

Female Ejaculation

One of the most exciting reports coming out of the current Grafenberg Spot research is that some women have the capacity to ejaculate. There has been speculation about this point for many years, and women who did experience copious, and sometimes spurting, secretions have worried about whether they were normal or not. Finally, there is evidence to show that this is a normal, and attainable, sexual experience.

Researchers note that women who actively stimulate their Grafenberg Spot in lovemaking tend to report ejaculation more often than do other women. Also, investigations have led them to conclude that the spot is actually a female equivalent of the male prostate gland. In the male, this gland is responsible for producing most of the fluid that constitutes semen; in some women, at least, the Grafenberg Spot functions in much the same way, producing a volume of fluid that is ejaculated at the point of orgasm through the urethra.

Because the fluid comes through the urethra, many people have assumed that it was urine. Women, in particular, were embarrassed, in some cases even holding back their own orgasms and teaching themselves after some unpleasant experiences to ignore the sensations their Grafenberg Spot gave them. But the fluid has been tested and it is not urine, but rather a clear substance that has many of the same chemical ingredients as male prostatic fluid (without the sperm, of course).

Our misunderstanding of this phenomenon may explain why many women have had trouble reaching orgasm. If you're one of those wet women, don't be anxious: If you've emptied your bladder prior to lovemaking, and have developed your PC muscle, the fluid is not urine, and you can relax and focus on the lovely, total-body sensations your Grafenberg Spot gives you when it is actively stimulated.

G-Spot Positions of Intercourse (starting on page 54): 8, 9, 11, 12, 17, 18, 19, 22, 28, 29, 35, 43, 45, 46, 47, 59, 60, 61, 64, 66, 76, 78, 79, 84, 85, 90, 93, 95, 96, 98, 102, 103, 104, 105, 106, 110, 116, 118, 121, 122, 123, 124, 126, 149, 150, 151, 152, 153, 154, 155, 156.

Voyeur & Lover INTIMATE VIEWS OF LOVE

They looked up into the sky, whose floating glow Spread like a rosy ocean, vast and bright; They gazed upon the glittering sea below, Whence the broad moon rose circling into sight;

> They heard the waves splash, and the wind so low, And saw each other's dark eyes darting light Into each other—and, beholding this, Their lips drew near, and clung into a kiss;

A long, long kiss, a kiss of youth, and love, And beauty, all concentrating like rays into one focus, kindled from above; Such kisses as belong to early days,

> Where heart, and soul, and sense, in concert move, And the blood's lava, and the pulse a blaze, Each kiss a heart-quake – for a kiss's strength, I think, it must be reckoned by its length.

> > They feared no eyes nor ears on that lone beach, They felt no terrors from the night, they were All in all to each other: though their speech Was broken words, they thought a language there—

And all the burning tongues the passions teach
Found in one sigh the best interpreter
Of nature's oracle-first love-that all
Which Eve has left her daughters since her fall.

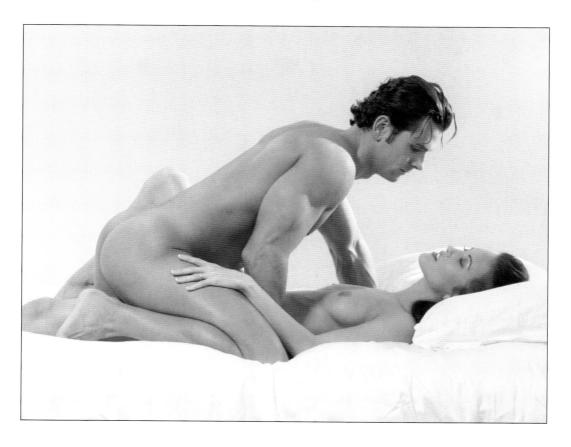

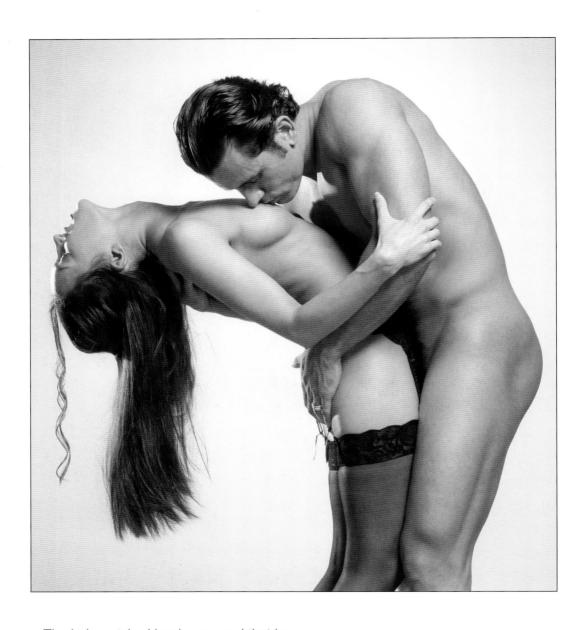

The lady watched her lover – and that hour Of Love's and Night's, and Ocean's solitude, O'erflowed her soul with their united power; Amidst the barren sand and rocks so rude

She and her wave-worn love had made their bower, Where naught upon their passion could intrude, And all the stars that crowded the blue space Saw nothing happier than her glowing face.

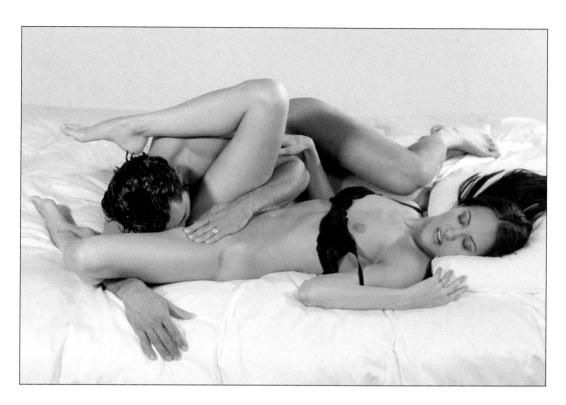

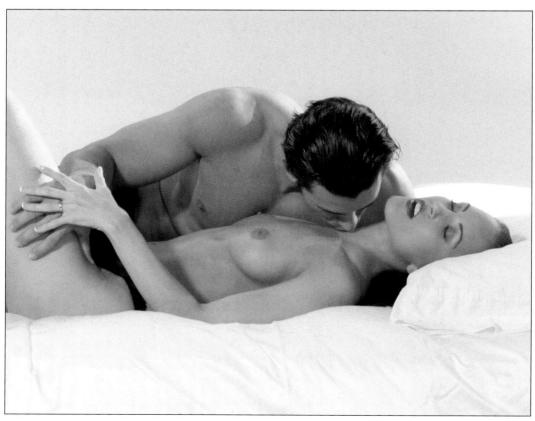

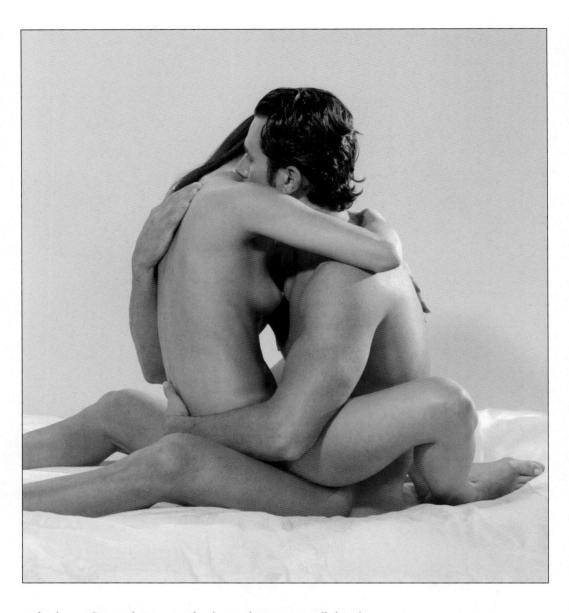

And now 'twas done – on the lone shore were plighted Their hearts; the stars, their nuptial torches, shed Beauty upon the beautiful they lighted: Ocean their witness, and the cave their bed,

By their own feelings hallowed and united, Their priest was Solitude, and they were wed: And they were happy, for to their young eyes, Each was an angel, and earth paradise.

- from George Gordon (Lord Byron), "Don Juan: Canto II"

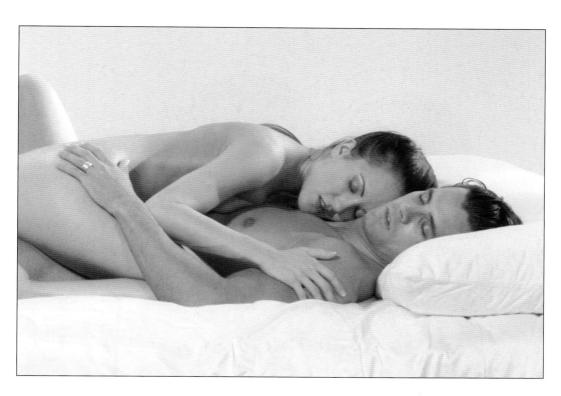

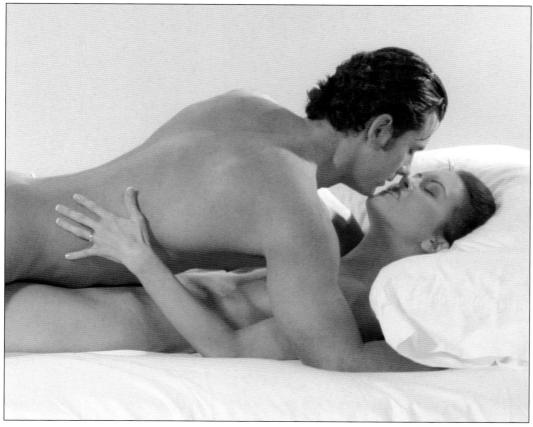

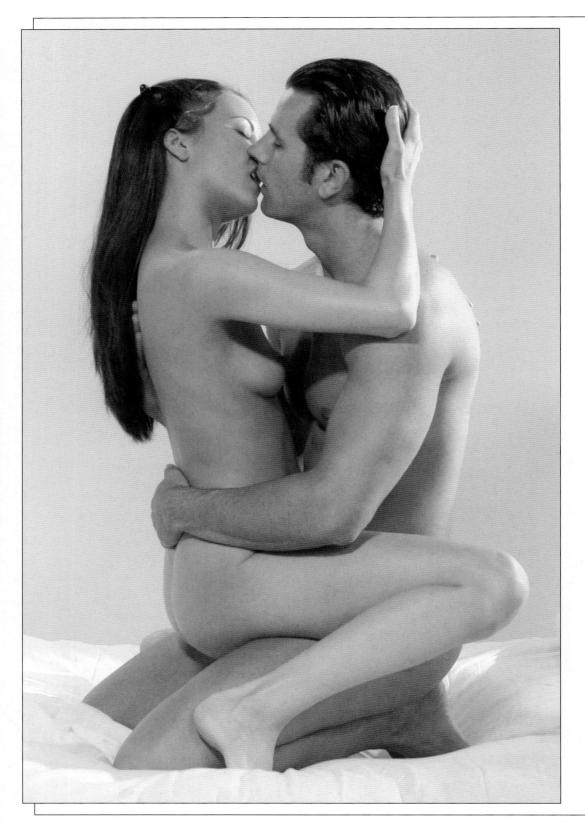

The Intimate Appointment VAGINAL

ENTRY POSITIONS

It's always a special moment when a lover enters me. My vagina is swollen and moist, my body is soft—all of me is aching for him to come in, to be inside, to fill me with his full length and move in concert with me. As many times as I've experienced this sensation, there is always something unique about the first penile probing of my vagina; the feeling of stretching as the head goes in, the warmth that spreads over my entire body, that solid feeling as his sex meets mine.

'it is always a unique sensation when his penis first enters my vagina'

Not all lovemaking positions have been equally wonderful, of course. Some have been more trouble than they were worth, and some were good only for a laugh. But some, even those that didn't look very promising, turned out to be dynamic and proved to me that we are always capable of new sensations and pleasures.

New intercourse positions can't cure everything that's wrong with a sexual relationship. If you and your lover aren't getting along, if there's a lack of trust or no sense of play in bed, if one is indifferent to the other's needs, no quantity of positions will make much difference. But some problems – a bit of boredom, perhaps, or a lovemaking routine

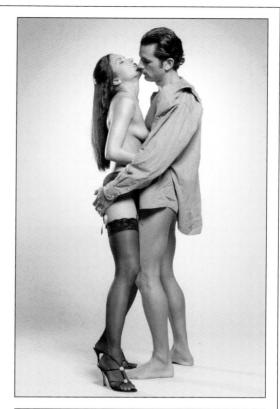

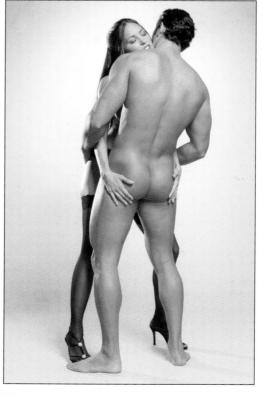

that doesn't stimulate her enough or doesn't give him deep enough penetration – can often be solved by a touch of novelty and some attention to individual physical and psychological needs.

The Return Of The Missionary

For a while, it looked as if the missionary position was actually going out of style. And that really would have been too bad. Not only is it satisfying in so many ways, but it lends itself to some very exciting lovemaking variations. With your basic missionary positions (see pages 52-57), you can touch your partner almost everywhere; she can fondle his face, ears, and chest, and reach around to grab his bottom, and he can kiss

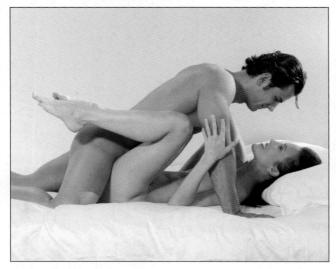

her face and breasts and ears and neck. The two of you can look at each other directly, whisper the thoughts that come to mind, and register each other's reactions immediately. And she isn't confined to a passive role – as much as he thrusts down, she can thrust up, matching his rhythm, countering with her own backbeat, filling herself with his penis.

Clitoral Stimulation

Some women can't get the proper angle for clitoral stimulation or Grafenberg Spot stimulation with a standard missionary position, however. They need penile friction closer to the front of the vagina, where the nerves that lead to the clitoris are located (and indirectly stimulate it), as well as around the Grafenberg Spot. For their orgasms, variations are in order.

Doing Your Legwork

The most obvious thing to do, ladies, is to vary the position of your legs. In a conventional missionary position, your legs are either around his hips or bent at either side of them. If you're limber through the hips and thighs, try lowering your legs to either side of him, keeping your knees bent and

'as he thrusts down, she can thrust up, matching his rhythm'

turned outward, seeing how close you can bring them to the surface of the bed or floor. This pulls your hips down and makes his

penis rub harder against the upper wall of the vagina.

With your knees out of the way, he can not only move in and out but also side-to-side. This can be very thrilling to him as well as to you, but the angle sometimes makes the position seem insecure to him-he often feels as if he might fall out at any time. Use this position, men, to experiment with slow thrusting (which is a special talent of its own and has its own distinct sensations), at least until you feel more comfortable. She'll be able to feel every inch of your penis as it slides slowly back and forth, and she can especially feel the extra width of the coronal ridge. You can

speed up gradually (á la Ravel's Bolero), or suddenly, to drive her crazy.

Deeper Penetration

Or, if it's deeper penetration you want, bring your legs up higher. You can rest your legs along the sides of his torso, with your knees tucked in his armpits; put your legs over his shoulders; or double them up as far as they will go on your chest. The feeling of being deeply penetrated is often very exciting for a woman. Likewise, the opportunity to thrust so deeply and directly is psychologically, as well as physically, exciting for many men. The first such thrust should be a little slower—I can tell you from personal experience that the feeling of deep penetration is like nothing else, and I want to have time to savor it.

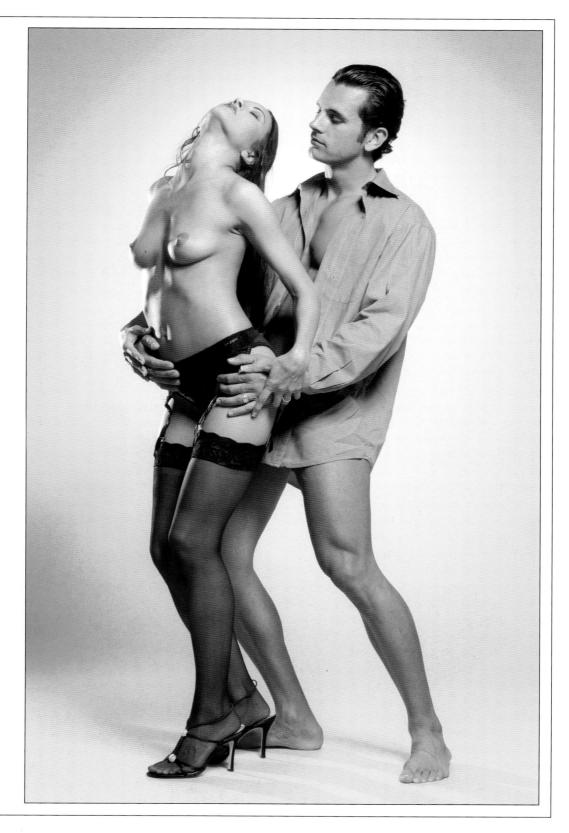

A few words of caution, however: it is possible for the man to thrust too hard in this position and hit an ovary. Some women compare this sensation with that of being kicked in the testicles (meaning, it's extremely painful). In any case, be careful. Also, some women object to a position with their legs up in the air because they don't feel very graceful. This is not a trivial point; if a woman feels ridiculous, her mind is not going to be on enjoying sex. Of course, increasing her arousal will soon get her to the point where her appearance at the moment has a diminished importance; however, there's no point in being counterproductive at the beginning.

If it's a feeling of tightness you want, he can move his legs. Enter her the conventional way and when you feel secure in her vagina, have her gradually put her legs flat on the bed or floor, fully extended, while you move your legs to the outside of hers. The man's legs should also be flat (or relatively so) on the surface, and extended. With her legs closed, she can squeeze your penis even tighter, using her thigh muscles as well as her PC muscle. This position is sometimes hard to achieve, though, and thrusting is more difficult. However, you may not even need to thrust, as the combination of her position and well-trained PC muscle may be all that's necessary to put you over the edge.

This next variation is easier and is one of my favorites because it combines exquisite tightness with more freedom for movement. Gentlemen: this time, put only one leg on the outside after you've entered your lady; someone looking at you from the top (an interesting fantasy...) and counting legs would see his, hers, his, hers. This way the pressure isn't quite as strong (which should enable you to last longer), the angle is more convenient (so that you feel less likely to slip out inadvertently), and you have more freedom to move and thrust. I climax very quickly in this position, and I invariably want more immediately.

Push-ups

You can also vary your experience by how you hold your torso. For a brief period at least, most men can support themselves on fully extended arms; if you arch the small of your back a bit, both partners get a lovely view of that most erotic of all sights—your penis sliding wetly in and out of her vagina, shining with her lubrication. While you're in this position, the man can also lower his head far enough to kiss the woman's breasts. A delightful dual sensation!

For prolonged intercourse, it's probably more comfortable for the man to rest on his elbows. He can kiss her face and throat from this distance and rub her nipples with his

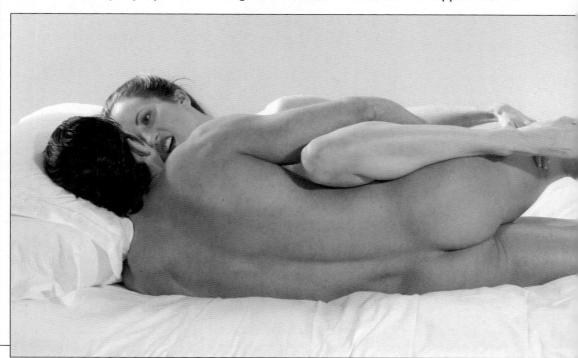

own – if he's at all sensitive in that area, a little nipple-to-nipple stimulation can incite both of you to greater levels of passion.

Depending on your weight, gentlemen, you may also be able to lie on top of her in a full-length embrace. I find that men often like to do this just as they're about to orgasm, and even with the increased weight on me, I welcome it—I want my lover as

'slow thrusting is a wonderful way to build arousal'

close as possible to me at the moment of ejaculation. I also want to stay near as we come down from our orgasms so that we can stroke each other, whisper in each other's ears, and cuddle. If a woman's breathing becomes labored, however, that's a clear signal for him to take the pressure off. And, stay alert, men; full-length cuddling is wonderful, but crushing your partner by falling asleep on top of her can damage a relationship.

Rollovers

You can get a different sexual sensation by remaining in the same face-to-face orientation, but just rolling over sideways. This is nice when he's tired of supporting his

weight and of extended thrusting; you can get back into a standard missionary position whenever you're ready without having to reconnect.

But a sideways position is not just for relaxation. The woman can thrust as hard as the man and can adjust the angle better than when she is underneath. Both of you can move your torsos back away from each other a little to allow deeper penetration, as well. However, her leg may be supporting his weight, and there might be a limit to how long she can do this. If the leg goes numb, give her a break, men, and roll into a new position.

Bedside Manners

If you've got a bed available and it's the right height, you can try a variation that involves him standing. She should lie on her back with her buttocks right at the edge of the bed, her knees drawn up. He enters while standing, and she hooks her legs around his hips. Since he's standing, he can move any way he pleases, and if he feels particularly strong, he can reach over and pick her up off the bed! This is an exciting and unexpected thing to happen to a woman, but not all men feel comfortable trying it. If you have any doubts, men, remember that your woman would rather have an unfulfilled fantasy than see you injure your back.

Lawn Swings & Sitting Tangos

Another dimension in face-to-face positions opens when the woman sits up. One of the nicest examples of this is what I call the 'lawn swing'. You'll see why in a minute.

The man should think ahead a little for this one. Starting from a conventional missionary position, he sits up, and brings both legs **forward**, one at a time, so that the soles of his feet are flat on the surface; knees are bent, and he's sitting facing her. He leans back and supports his torso with his hands. As he reaches this pose, his lover sits up and supports herself the same way. It's possible to perform this feat without disengaging penis from vagina, but if you don't succeed, it's no problem. Just put it in again.

With your weight on your hands and feet, you're free to bring your hips up from the bed or floor and move them any way you please. This leads to sensations unlike any others I've experienced; because your hips are free of support, you can't slam into each other so hard, and the thrusting movement

has a fluid, 'seamless' quality that's quite dreamy. I can go on and on in this position, in a weightless state of arousal, with no desire to quickly come to an orgasm.

Another posture that I call the 'sitting tango' (because it reminds me of Brando and his lover in **Last Tango**) has its own special attractions. With both partners sitting up as in the lawn swing, scoot up, still connected, so that you can hug tightly; usually her legs go over his. It's almost impossible to get any movement going in this position, but it feels so cozy that you won't mind. And, if you feel an overwhelming urge to thrust, the man should lean back a little and have the woman sit up, right on his hips, where she can bounce herself (and him) into ecstasy.

Turnabout Is Fair Play

Intercourse with the woman on top appears to be running neck-and-neck with the missionary position for current popularity. People are finding that there are special charms to letting the woman ride her man. Men have told me that they love the closeup view of their lovers' breasts swaying above them; the angle makes her bosom appear larger, and a man can kiss and lick her breasts to his heart's content. Also, there are few better positions for her to tantalize him-by caressing his body with her breasts and hands, for instance. He can't really be too active, and a perceptive woman who knows her man well can keep him on the edge for a long time without him being able to do much about it.

One of the few things he can do is grab a handful of derriere (gently, now), and pull her toward him when he really wants to thrust deeply. And those men whose women have long hair feel like they're making love behind some kind of exotic curtain when their woman bends down over them. The heat builds up inside the circle of her hair, and the soft light filters through in shifting patterns as she moves over him—it's a tremendously erotic experience, and one I recommend highly.

There are a number of ways to get into a woman-on-top position without starting from the beginning. You can get there directly by straightening both pairs of legs, clinging tightly together and rolling sideways 180 degrees, into the new position. Adjust your legs once she's on top. The sideways positions put you halfway there already.

'I want my lover
as close to me as
possible at the moment
of ejaculation'

Or, you could go the other way via the lawn swing or sitting tango position. From these positions, he just lies back; she moves forward until her weight is on her knees and continues to bend over him until she is fully on top.

As you get more comfortable with various positions, you'll discover more combinations that you can perform effortlessly. One of the nicest things about intercourse is how so many positions lead to other positions. And why settle for one kind of stimulation when you can get several different kinds in a row? By skillful variation you can make your lovemaking fast or slow, simple and relaxing, or unexpectedly complex—in short, you can orchestrate any sexual experience you want.

When I'm on top, I like to make a long and drawn-out ceremony of inserting my man—the moment he enters me is a special one and I'm not about to rush it. When I'm ready for him, I straddle his erection and gently cup his genitals with my hand. I may move slowly down and kiss his upper torso; or perhaps I'll kiss the head of his penis

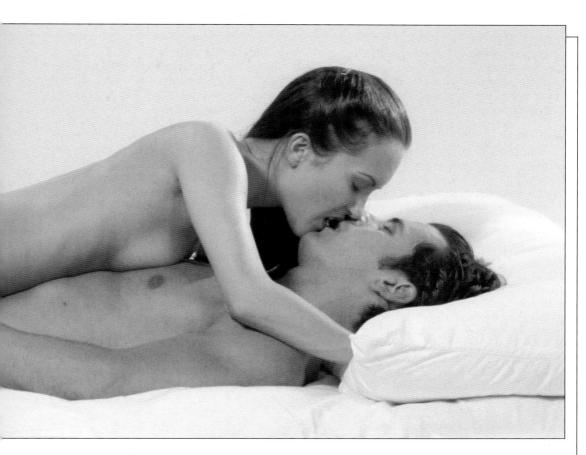

(see Chapter 7 for more ideas). Or, I may just tease him with my hand (I'll discuss 'hand-jobs' in more detail later in this chapter). And then, instead of just putting his penis into my vagina, I first use the head to massage the vaginal lips, stroking myself the length of my labia. This gets him on the most sensitive part of the penis – the coronal ridge – and the motion will drive him wild. Often, I'm so aroused at this point that I don't need to pleasure myself very long before I orgasm – and if there's one thing men like, it's watching their lover reach climax.

After I've climaxed, I can't wait (very long, that is) to feel his penis enter my vagina, so I put just the head of the penis in and squeeze with my PC muscle. He wants more, but I tease him, take him out again, and resume my firm stroking. Then I slide the head in a little deeper until I can squeeze farther down the shaft, and so on. If he's approaching ejaculation by this torture too soon for my needs, I let him cool off a few minutes between each escalation while I pleasure myself, or let him do it. By the time I put him all the way in, we're both ready for

an all-out bump-and-grind session. Many times, we can come together in total, shivering abandonment.

Twist & Shout

Once you're up there ladies, there's no need to stay in one place. If he likes a good close-up of your curvy bottom and access to it with his hands, twist around so that you're facing his feet, still on top of him. While you're facing in that direction, you can suck on his toes.

Or, try this one for a really different experience. While you're still connected to him in a conventional woman-on-top position (it's important to stay connected for this one to work), swing your legs forward to either side of his torso and lean back (see page 61). Your legs will be over his. Now hold hands with him for leverage and pull yourselves toward each other. You won't be able to move at will—the friction of your body on the bed or floor is too great for that—but you can change your position enough to stimulate each other, and many gentlemen love that downward pull on their penises which,

combined with slow but steady pelvic movements, can lead to explosive orgasms! This position also puts a lot of pressure on the upper wall of the vagina and leads to greater clitoral stimulation.

Rear Entry

You don't have to feel aggressive and earthy to enjoy rear entry; you can be as tender, gradual and civilized as you like. But there's something about that sense of vulnerability that brings out the lower primate in

many of us.

Usually she's on her hands and knees or elbows and knees, her buttocks in the air. He can kneel behind her, or stand (if they're on a bed of the right height), with her knees positioned right at the edge of the bed. The man can hold onto her hips for support and leverage, or he can bend over her back, cupping her breasts from underneath for a double sensation.

Because of the angle (which hits the Grafenberg Spot most directly), or maybe because of those lusty animal feelings this

position often arouses (or maybe just because a woman's behind is so beautiful), both partners often reach climax faster and more powerfully while connected in rear entry. For this reason, it's wise to use some care, both in entry and in actual thrusting. Rear entry is another of those deep-penetration positions, so it's possible to hurt the woman by going in too deeply or too fast. Gentlemen, be cautious! And women, remember that he often loses control when he sees your lovely bottom swaying in front of him-don't expect him to hold out too long with such a view.

Rear entry affords other options for stimulation besides intercourse proper; for instance, she can reach back and stroke his testicles from underneath. Women must be careful when they do this, but should be aware that some men can take a little more intense pressure than they might expect. On the other hand, sometimes just the feeling of a warm female hand cupping the testicles is very arousing.

The man can do exquisite things to a woman's breasts in a rear-entry position. The position often makes the breasts more sensitive, and very light stroking-even barely brushing the nipples with the palm of the hand-can have a powerful effect. The feeling of his testicles slapping in time with the thrusting of his penis against her genitals is wonderfully erotic, too.

Sleepy-Time Sex

Paradoxically, another great example of rear-entry intercourse is when you're sleepy and next to each other in bed. Many lovers

sleep nestled against each other like 'spoons', and this leads naturally to a type of gentle sex that doesn't require a lot of fancy moves, but is still extremely satisfying relaxing. He lies on his side behind her, and reaches between her leas to stroke her labia and clitoris to encourage lubrication. Then he simply inserts his penis, hugging her from the back to give himself leverage. The angle is sometimes a little hard to manage, especially if the man has not yet reached a full erection. In that case, all the woman has

to do is bend forward a little, so that her torso is more perpendicular to his. Once he's entered her vagina, she can straighten again and press her back against his chest. Men, be sure to move very slowly in this position, and combine your thrusting with lavish breast-play and nuzzling of her neck. She'll love it!

If you feel the urge for face-to-face contact in the midst of all this, she can twist onto her back and drape her leas over his thighs without disconnecting. Then she only has to turn her head to touch her mouth to his lips.

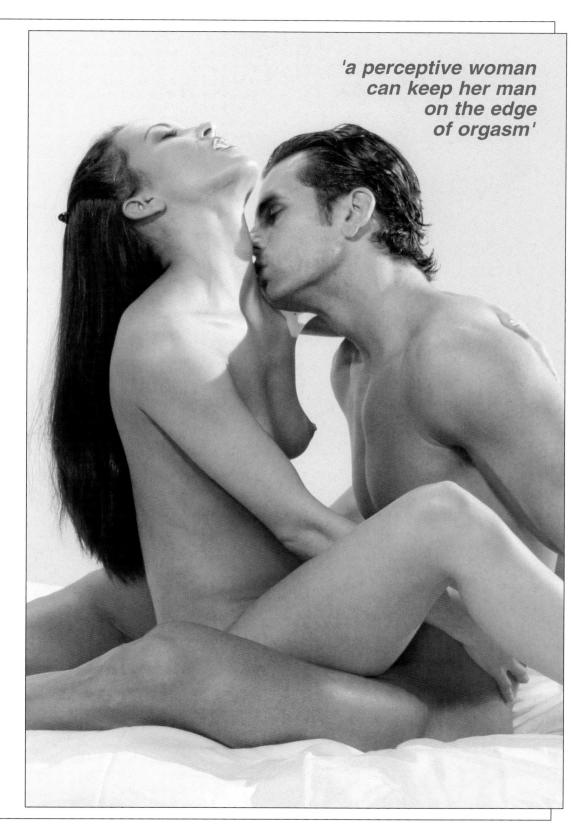

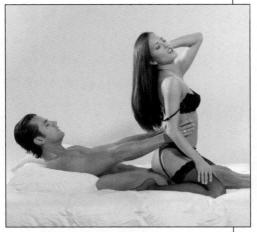

Alternatives To Intercourse

Inevitably, there will be times when intercourse or oral sex just isn't possible—because there's no time or suitable place, or there's a physical issue that precludes coupling. There's no need to give up on sexual contact at these times. The alternatives often have attractions of their own that make them more than just 'second best'.

Hand-Jobs

That old virginal practice of masturbating your partner is not just for adolescents. Women, you can use your hands to give your man the ultimate in controlled, step-

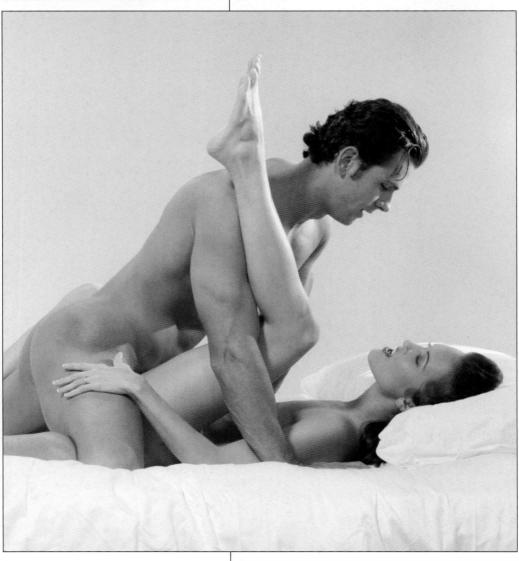

by-step escalation of sexual pleasure. Your hands are better coordinated than your vagina, and they don't tire as easily as your mouth, thus enabling you to give him complex and varied stimulation for as long as he can stand it.

A major consideration before you start is lubrication. There are a variety of safe, water-based and condom compatible lubricants available today. Some are even self-warming, which can add to your partner's arousal. (Note: Use only water-based lubricants.)

Treat a 'hand job' like a serious massage. Pour a little lubricant on one hand and rub your palms together before you begin to stroke his penis. He'll sigh audibly as he feels the warm, slick sensation, accompanied by the gentle pressure of your fingers.

'a hand job can give your man the ultimate in controlled escalation'

Start lightly, using the pads of your fingertips to stroke him up and down. You can try a few strokes without lubricant, but be careful-it's hard to undo the effects of chafing. The lubricant will slow the build-up of sexual tension, but watch carefully to keep his arousal under your control. Cover him with long strokes, short strokes, brushing strokes and little circles with your fingers. Discover his most sensitive spots and increase pressure slowly. Hold his penis in both hands, thumbs meeting in front on the underside, and rub very slowly up and down, slowing even more when you get to the top, just under the coronal ridge. Keep an eye on his reactions – it may be all he can do to lie still at this point.

As he gets closer to orgasm, a few drops of pre-ejaculate may appear on the head of his penis. Use the fluid as part of the lubrication, rubbing it in with the lubricant that is already on his skin. If the lubricant seems to be disappearing, reapply at any time. It's always better to use too much than to let the sensitive skin of the penis get dry and chafed.

After only a few minutes of stimulation, he may be close to climax. You'll see it in the tension of his hands and neck, hear it in his sighs and groans, and you will feel it in the way his penis swells and throbs in your hand and his testicles move up tightly against his groin. Without interrupting your consistent stroking, slow down a little to prolong these exquisite last few moments. Only when you're convinced that he's had as much as he can take should you speed up again and help him to climax. To enhance his orgasm, gently squeeze the lower edge of the coronal ridge to the rhythm of his ejaculations.

What to do with the semen? No problem. Catch it in your hands, your mouth, or have a towel, or tissues, or a handkerchief handy. On this note, a lover of mine once ejaculated unexpectedly and sprayed the wall. It didn't stain, and once I got over my shock, it was actually kind of funny.

Stay with him afterwards. You can continue to stroke him lightly, if he's not too sensitive (watch his reactions carefully). If things are too sticky, get a warm washcloth to wash him off and a hand towel to dry him. Wrap his penis loosely in a dry, soft towel and lie down full length next to him to let him feel the warmth of your body. With attention like this, your pampered partner won't mind the times when intercourse is not practical.

Fun With Cleavage

Another substitute for intercourse, or as a variation to be included during foreplay, is having him use my cleavage as a vagina. I rub water-based lubricant between my breasts, and while he sits above me, his weight on his hands and knees, I push my breasts together to make a tunnel for his penis. To hear men talk, you'd think it felt just like the real thing—warm, smooth, damp and enveloping.

I particularly like it because I have very sensitive breasts, and I get the chance to stroke my own nipples as I hold my breasts together. I can vary the pressure, too, to simulate the pressure of the vagina. Sometimes, I add an extra pillow under my head so I can give a quick amorous lick to the head of his penis as it emerges from the top of my cleavage. At his orgasm, I can take the semen in my mouth, my hands, on my chest, or in a towel or tissue.

Other Simulated Vaginas

Breasts are not the only substitute location for intercourse. Between her thighs or the cheeks of her buttocks can be equally pleasurable. Both feel a lot like vaginal intercourse to him and a little like anal inter-

course for both of you. If she really enjoys anal stimulation, you may be able to bring her to orgasm with just the stroking of your penis while using these methods.

People uncomfortable or unknowledgeable about anal contact should first read Chapter 8 (Anal Lovemaking). Otherwise, proceed as follows to try these techniques. The woman can be on her stomach or on her knees as in rear-entry intercourse. (Lubrication is always a good idea.) He guides his penis between the crease of her cheeks, squeezing them together to make a tunnel, or he can enter between her thighs from behind, as you lay side-by-side. Again, tissues or a towel may come in handy if this proceeds to an orgasm.

Caressing A Woman

Many women have nipples so sensitive

'rear entry provides the angles that best hit the Grafenberg Spot'

that breast stimulation alone can bring them near, or to, orgasm. Add a little manual stimulation of the clitoris to your suckling and you can drive her right over the edge. Start with a little licking around and across her nipples. You can use your mouth on one breast and your fingers on the other, pinching gently and rolling her nipple slightly between your fingers. She may want your pressure to increase along with her arousal. Listen carefully to her breathing (or moaning), and watch her face as you gently bite first one nipple, then the other. Add some

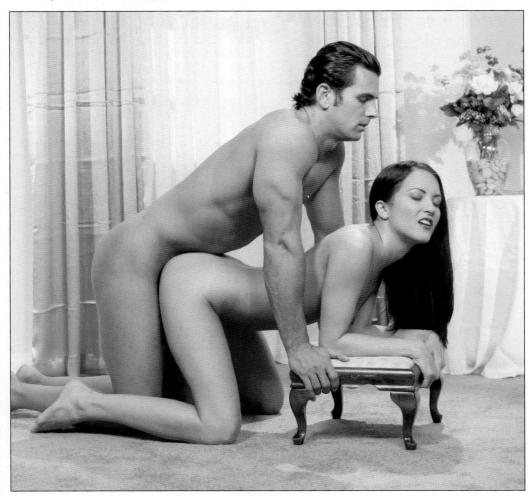

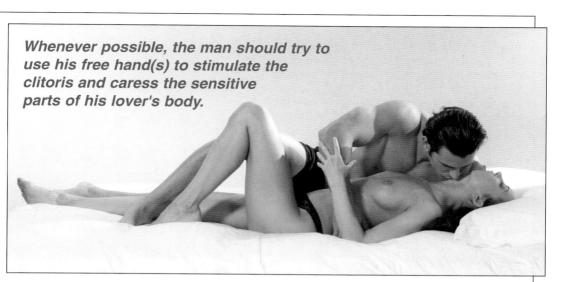

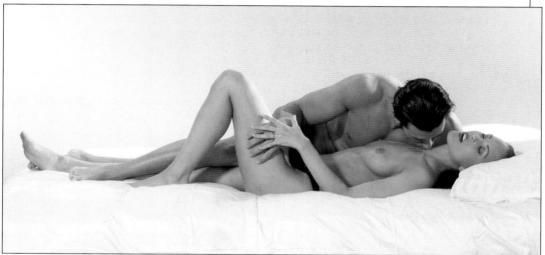

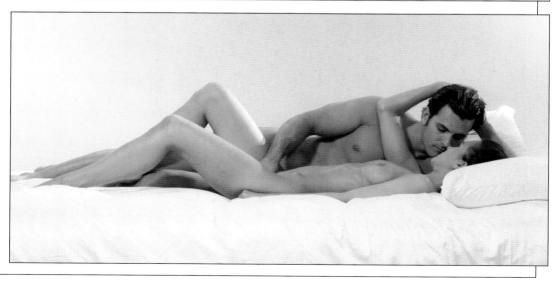

lubricant to your hand and tease her clitoris, rubbing gently, at first. Try both up and down and circular motions to see which she prefers. Again, too much lubricant is better than not enough. Move your fingers lower, and stroke her entire labia and beyond, toward her anus. By now, she may be straining against your hand and asking for your fingers in her vagina. (Be sure your fingernails are well clipped.) Keep pressure on her clitoris with the lower bone of your thumb and, while you stroke her, let her press against your hand until she reaches orgasm. Keep stroking her lightly, if she's not too sensitive, as you lie down full length and share your body heat. Finally, snuggle together while cupping her mons with your hand.

Spontaneous Foreplay

Imagine getting ready for a formal party with your lady. She's looking gorgeous in her evening gown and jewelry, with her makeup on and beautifully styled hair. You're in your best, too, and it's almost time to leave, but you want just a taste of lovemaking with her to let her know how good looking you think she is, and what you'll be thinking about at

'give yourselves a moment to enjoy getting half aroused'

the party. There's no time for full intercourse, and you don't want to undo all her careful preparations. What to do? Try going over to her and clasping her from behind. You can simply rub yourself against her fully clothed, or you can unzip your pants and pull up her skirt and slip. Nestle your penis between her buttocks and give yourself a moment to enjoy getting halfway aroused. The entire party will seem different as you catch each other's eyes and think ahead to what you'll do when you get home.

The same goes for you, ladies. Bring him over to you, fully dressed, and guide his hand up your skirt or down the front of your dress. Bend down, unzip him, and take his penis in your mouth for just a few seconds and a few warm licks. You may wind up coming home from the party earlier than you had planned! (Then again, you may never leave the house...)

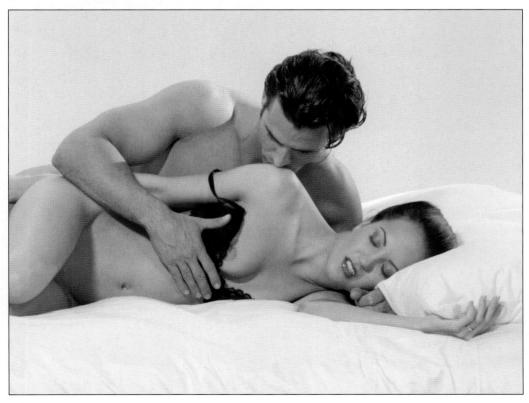

VAGINAL ENTRY POSITIONS

POSITION	PAGE	NUMBERS
Male Superior (Missionary)	52	1-21
Side-by-Side	58	22-29
Female Superior (Facing)	61	30-42
Male Superior (Opposing/Rear Entry)	65	43-47
Female Superior (Opposing)	66	48-54
Sitting & Squatting (Facing)	68	55-65
Sitting & Squatting (Opposing)	70	66-69
Standing	71	70-77
Kneeling	73	78-82
Edge of Bed	74	83-98
Wing Back Chair	77	99-107
Armless Chair	79	108-114
Rocking Chair	81	115-121
Footstool	83	122-126

MALE SUPERIOR-

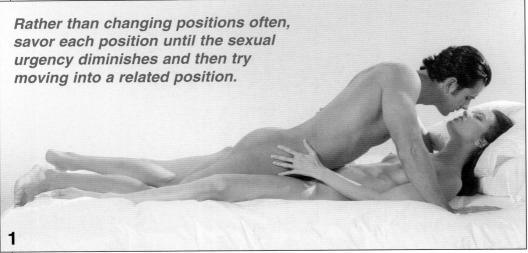

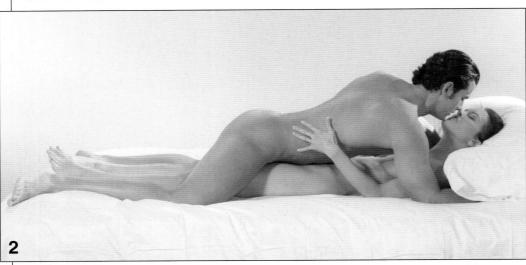

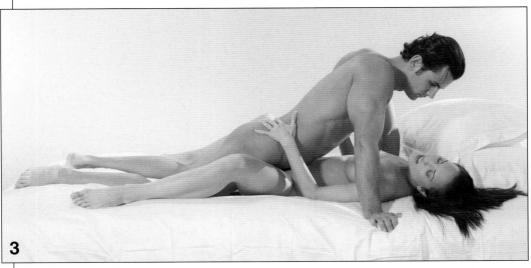

MALE SUPERIOR-

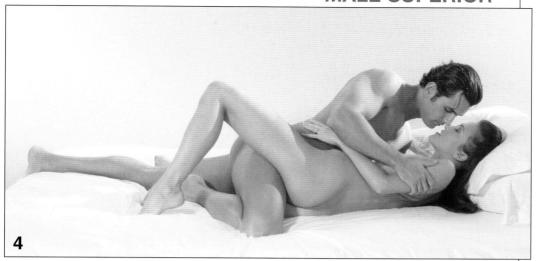

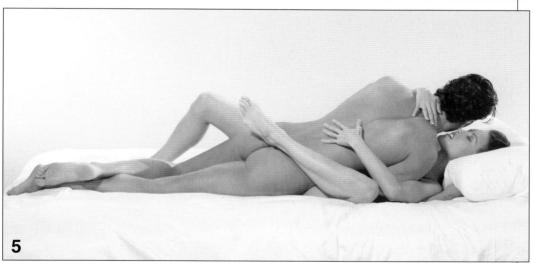

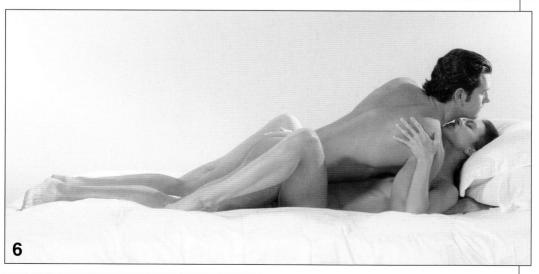

MALE SUPERIOR

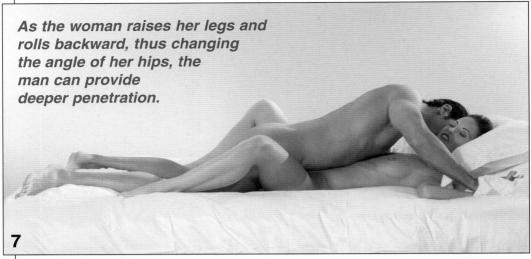

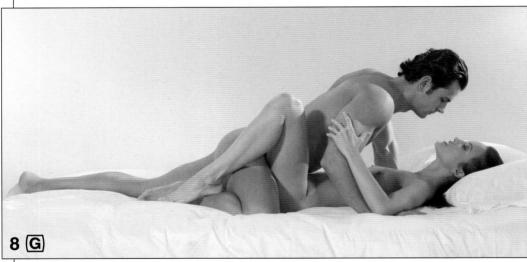

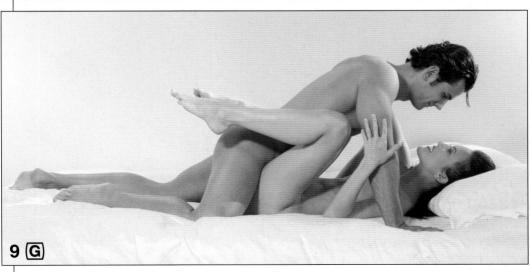

MALE SUPERIOR-

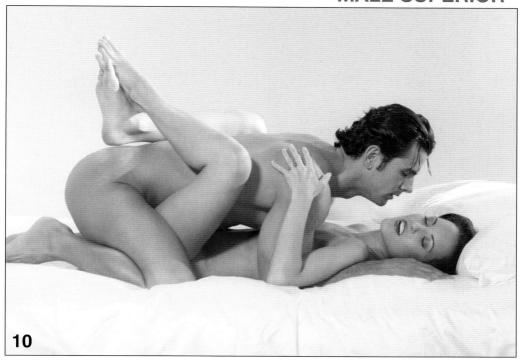

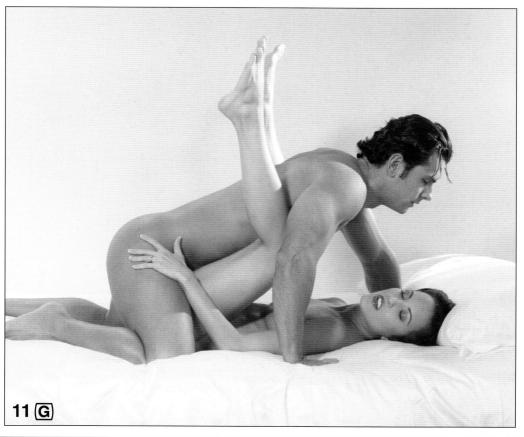

MALE SUPERIOR-

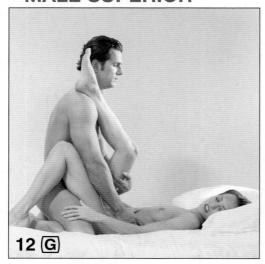

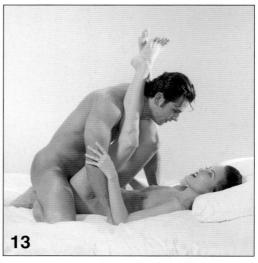

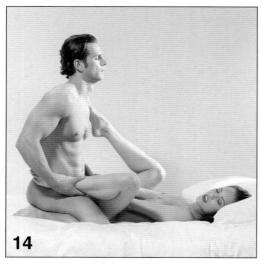

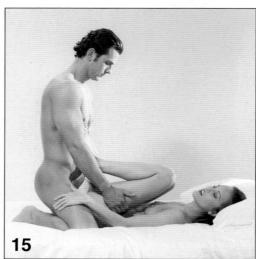

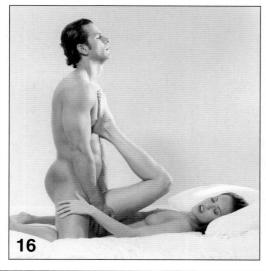

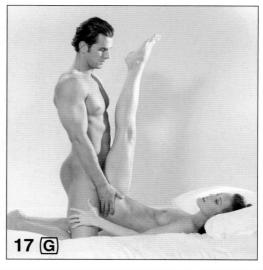

MALE SUPERIOR

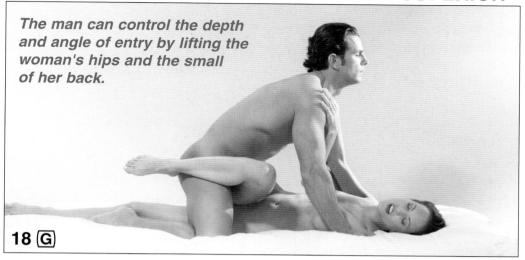

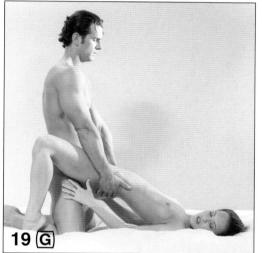

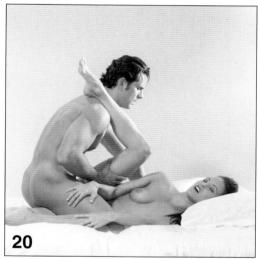

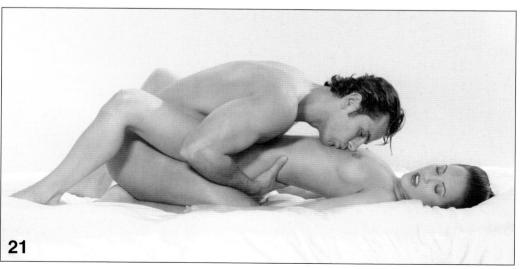

SIDE-BY-SIDE

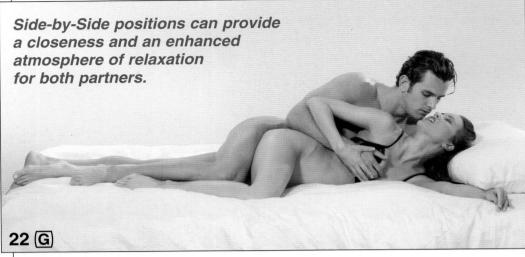

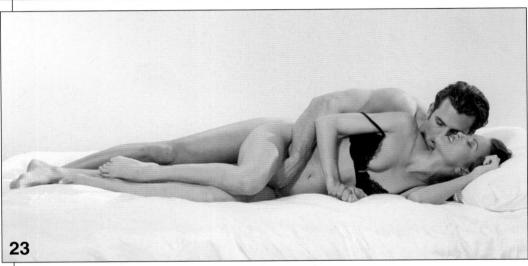

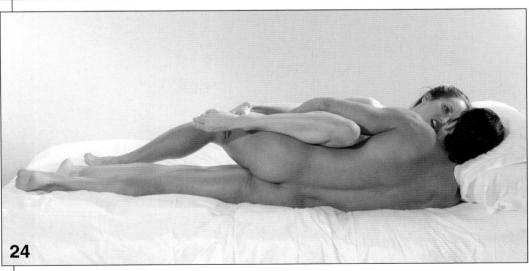

SIDE-BY-SIDE-

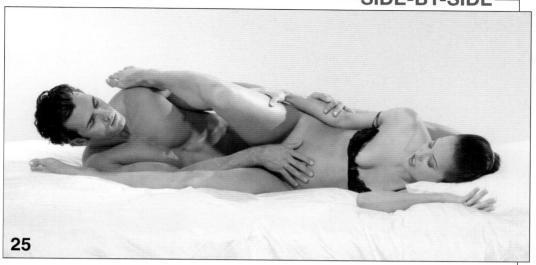

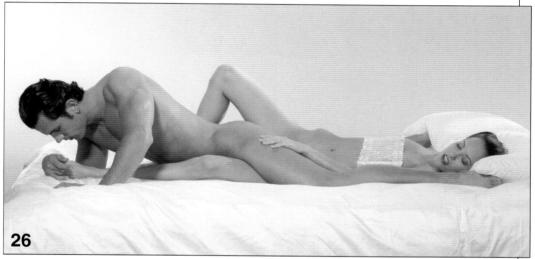

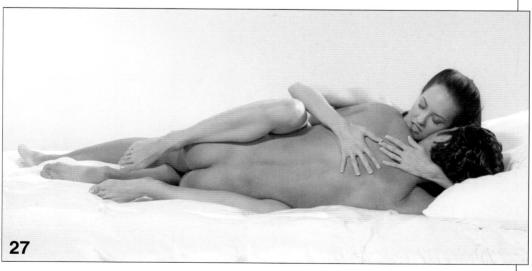

SIDE-BY-SIDE-

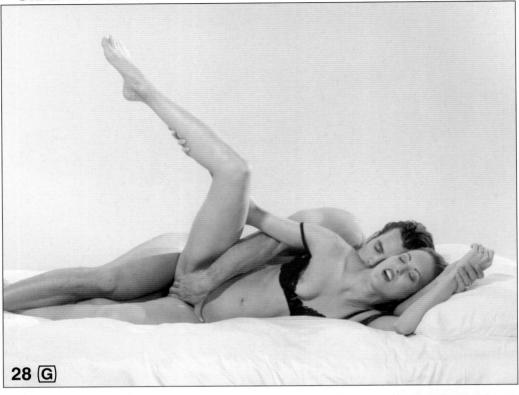

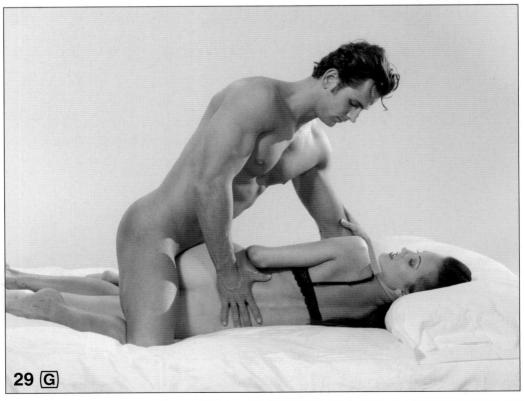

FEMALE SUPERIOR-FACING

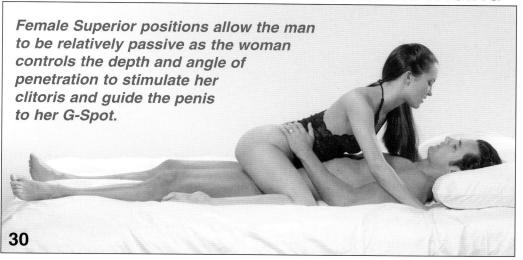

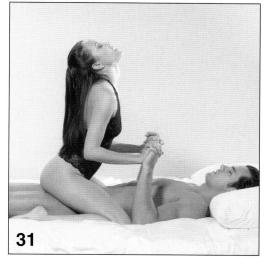

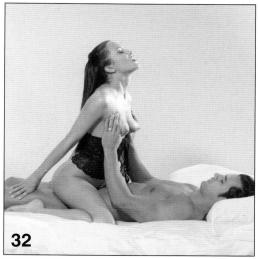

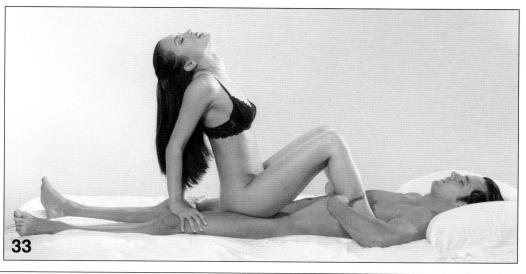

FEMALE SUPERIOR-FACING

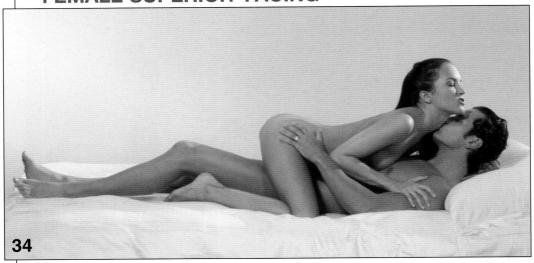

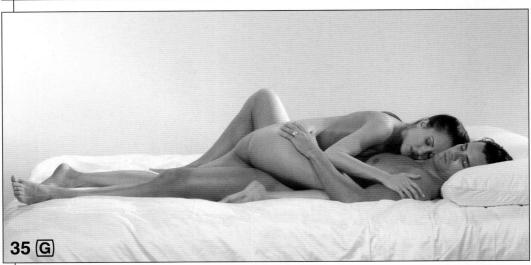

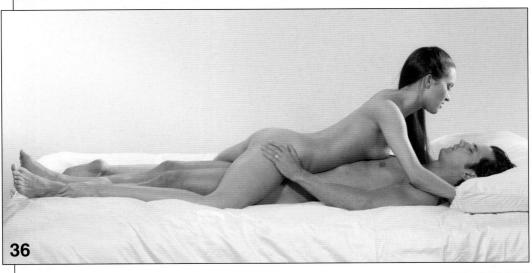

FEMALE SUPERIOR-FACING

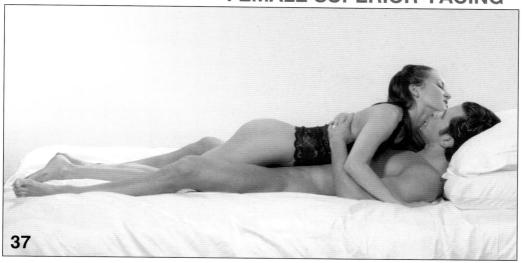

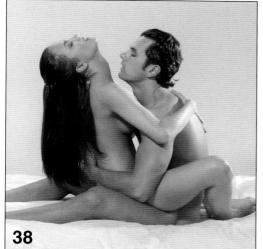

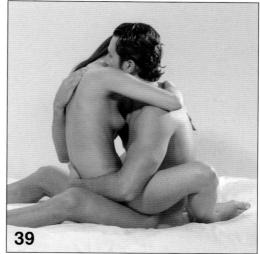

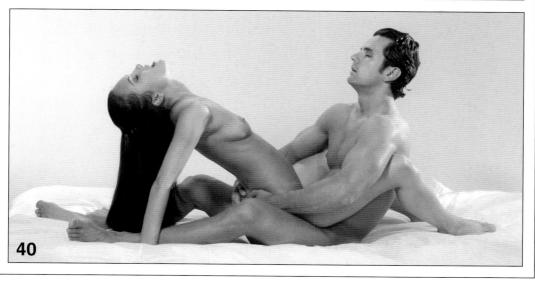

FEMALE SUPERIOR-FACING-

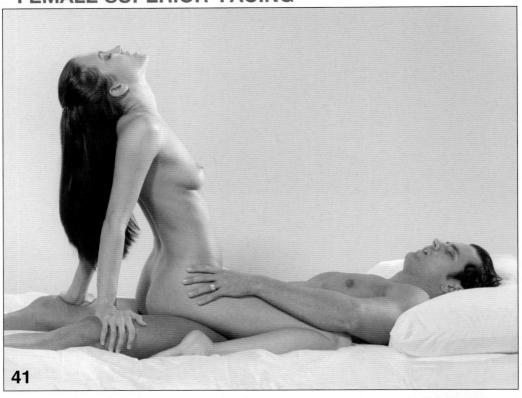

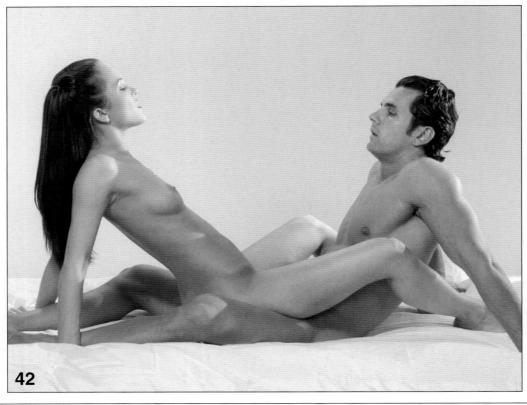

MALE SUPERIOR-OPPOSING/REAR ENTRY-

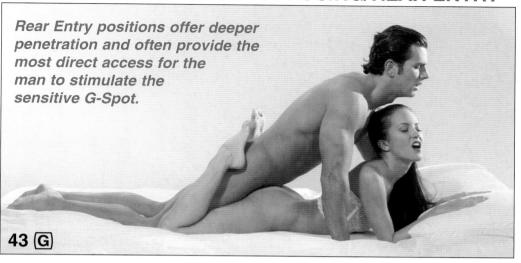

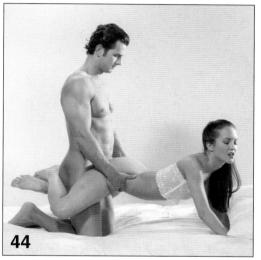

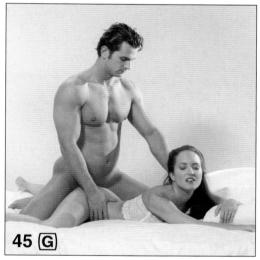

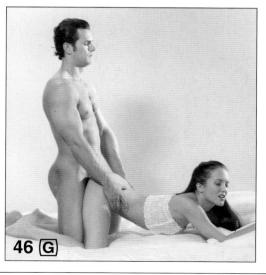

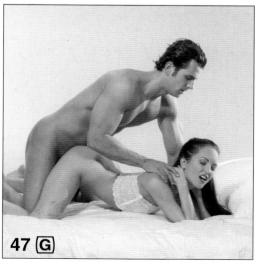

FEMALE SUPERIOR-OPPOSING

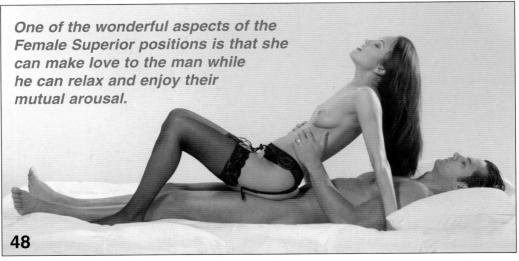

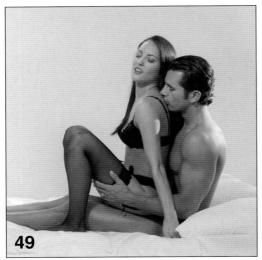

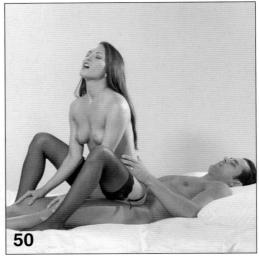

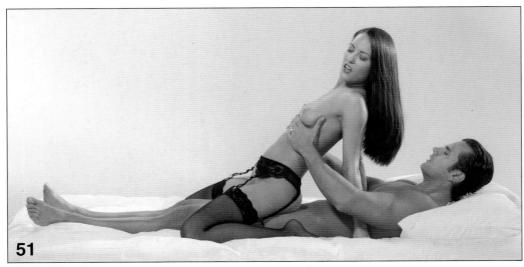

FEMALE SUPERIOR-OPPOSING-

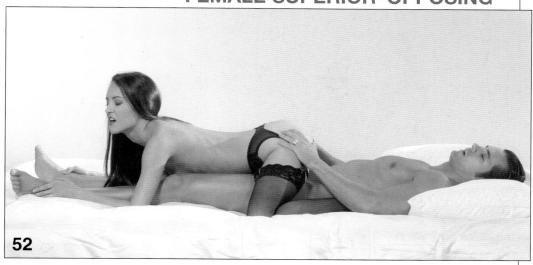

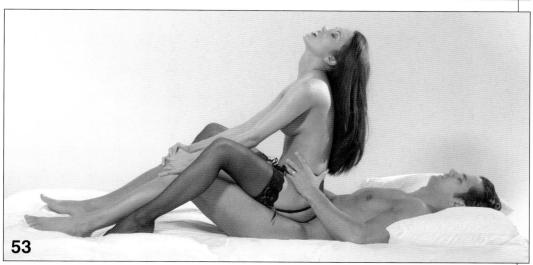

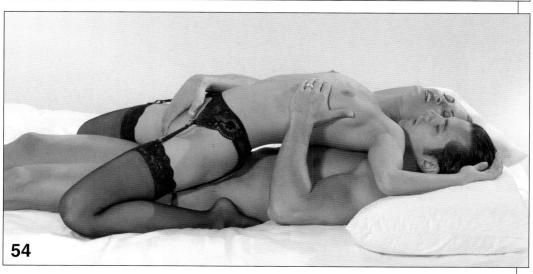

SITTING & SQUATTING-FACING-

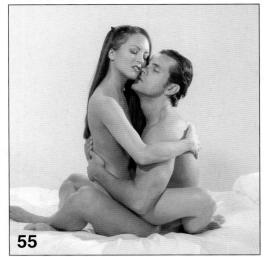

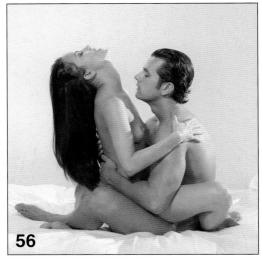

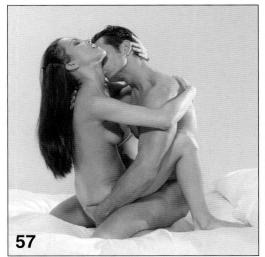

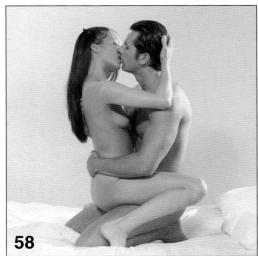

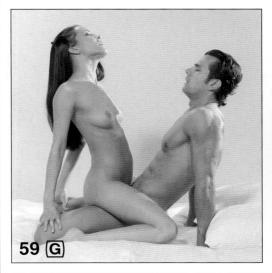

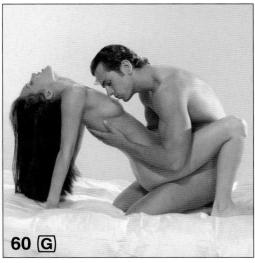

SITTING & SQUATTING-FACING

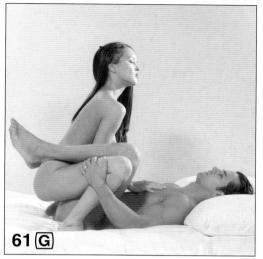

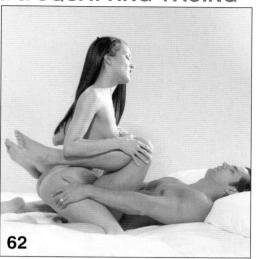

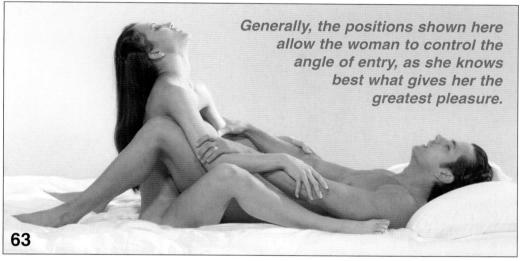

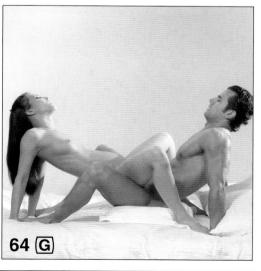

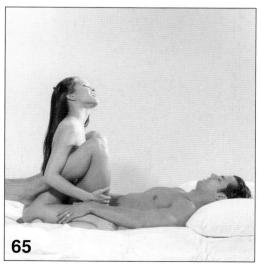

SITTING & SQUATTING-OPPOSING

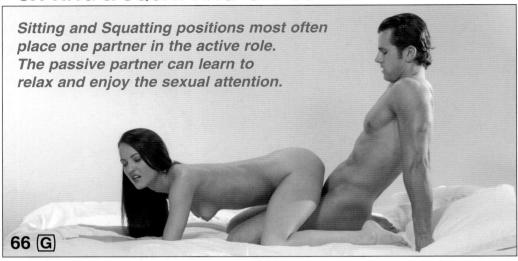

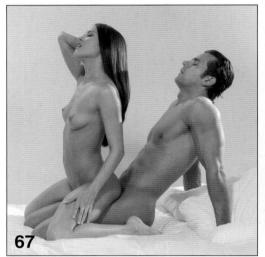

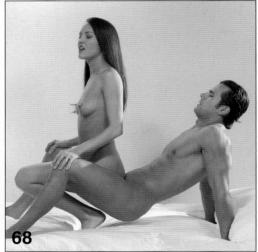

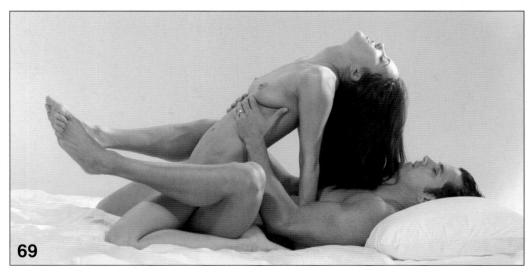

-STANDING-

STANDING

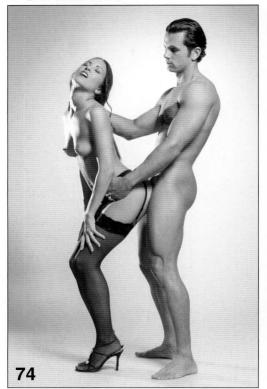

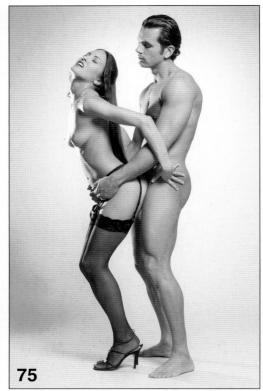

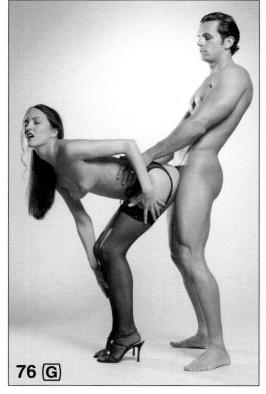

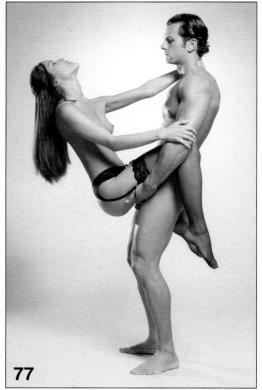

-KNEELING-

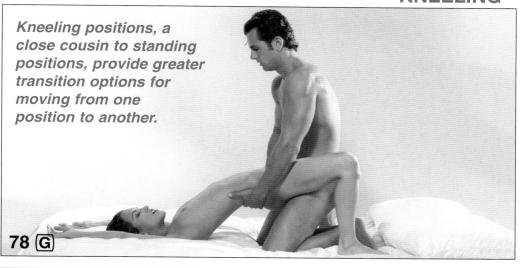

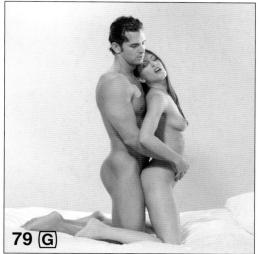

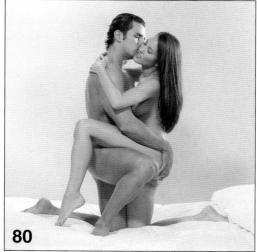

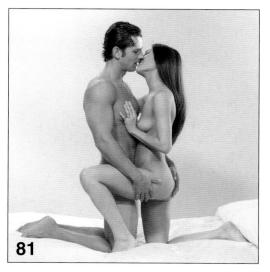

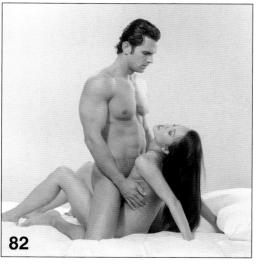

EDGE OF BED

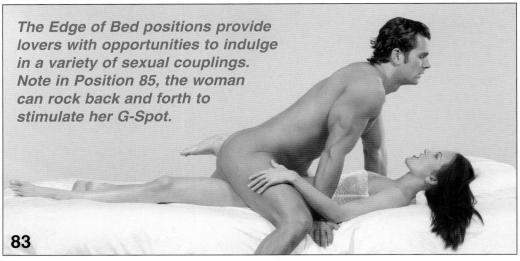

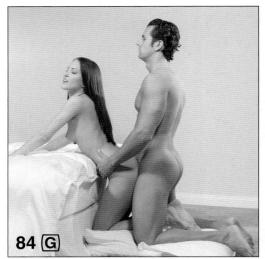

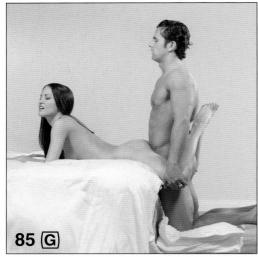

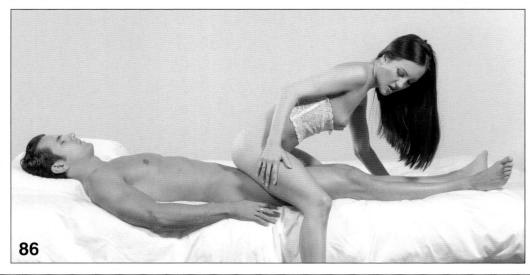

EDGE OF BED

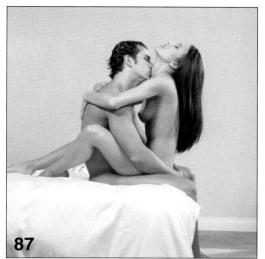

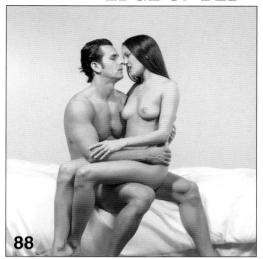

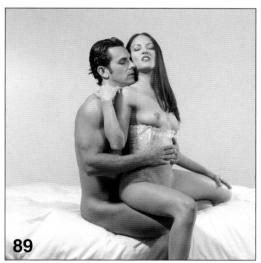

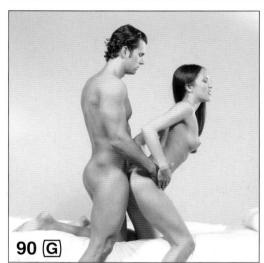

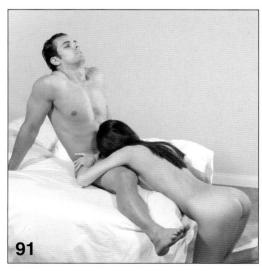

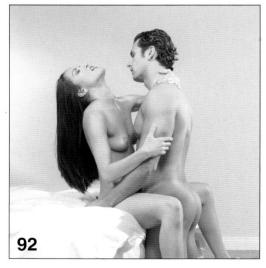

EDGE OF BED

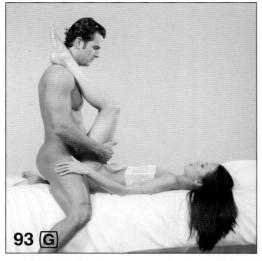

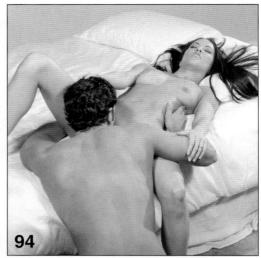

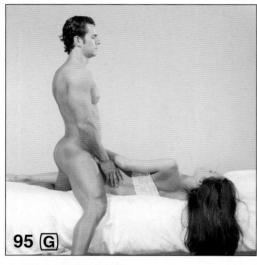

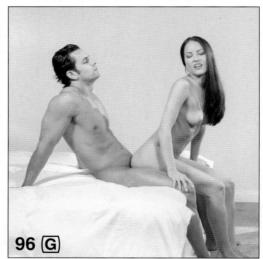

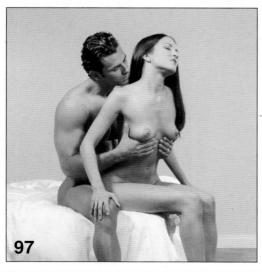

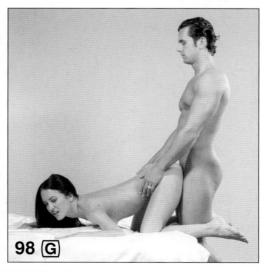

WING BACK CHAIR

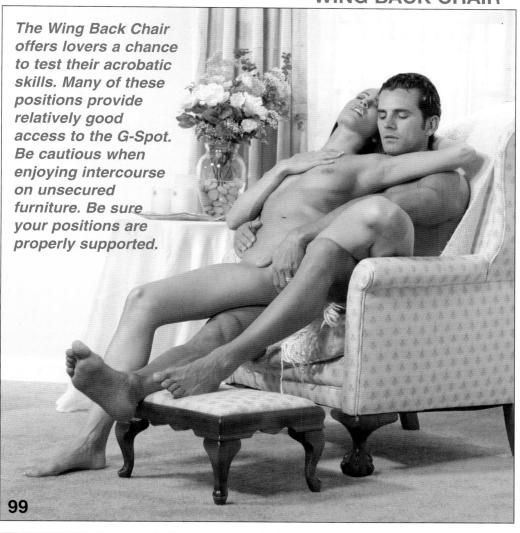

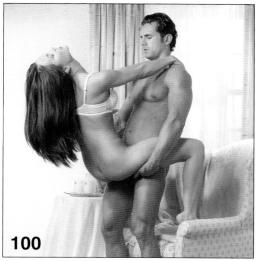

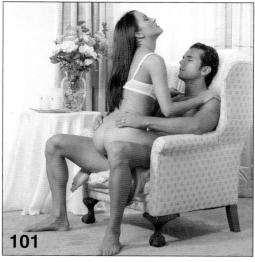

-WING BACK CHAIR-

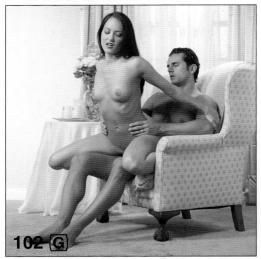

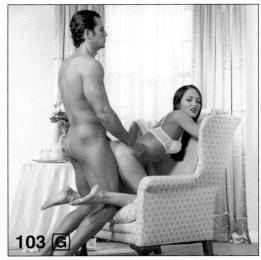

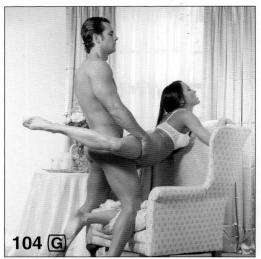

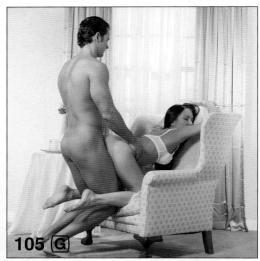

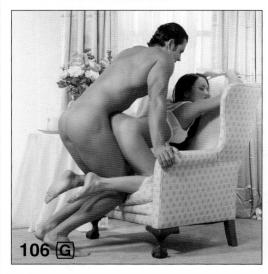

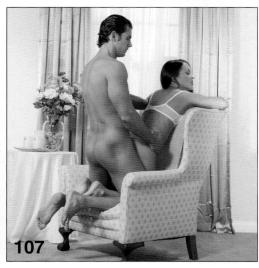

ARMLESS CHAIR-

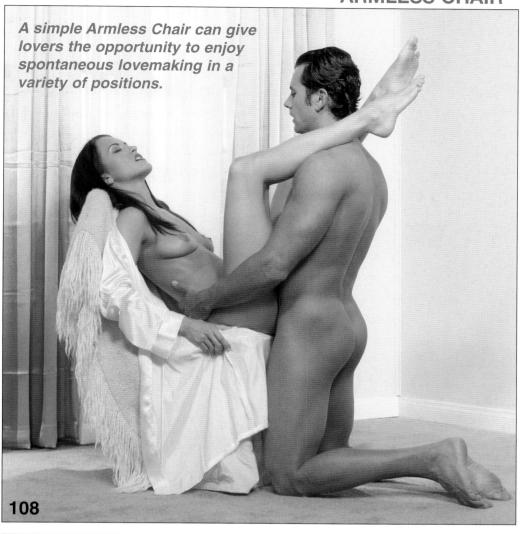

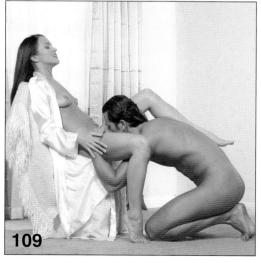

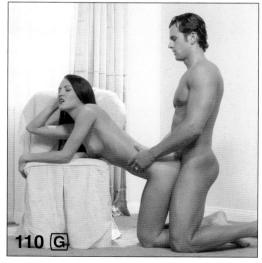

ARMLESS CHAIR-

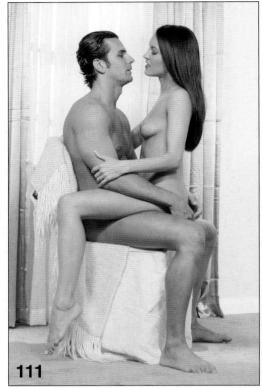

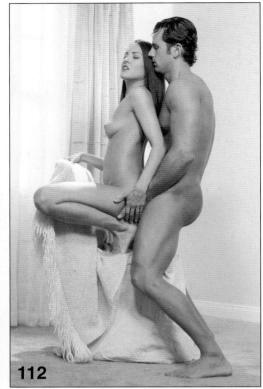

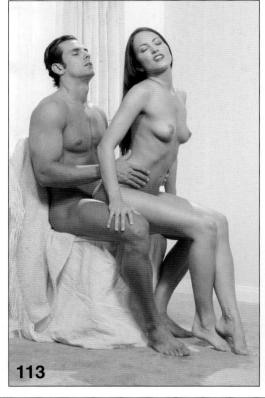

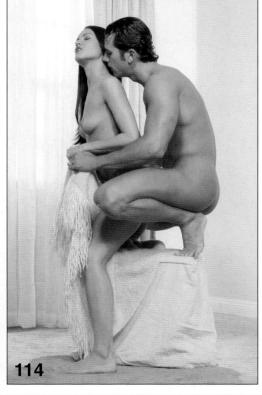

ROCKING CHAIR

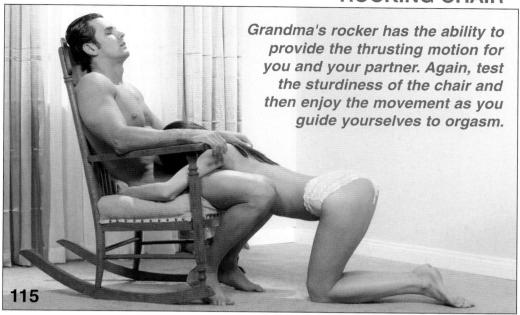

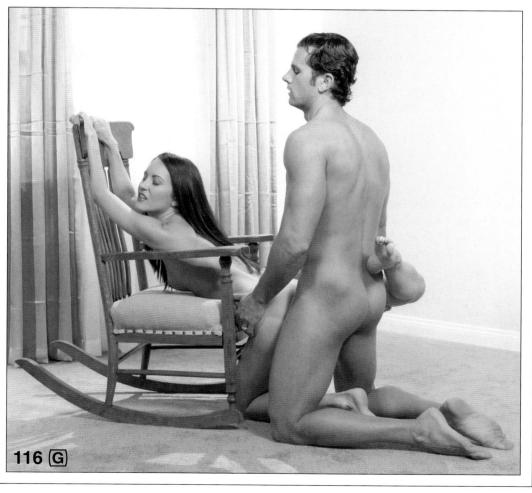

ROCKING CHAIR-

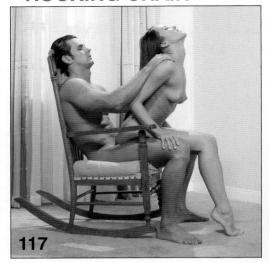

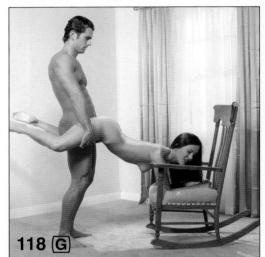

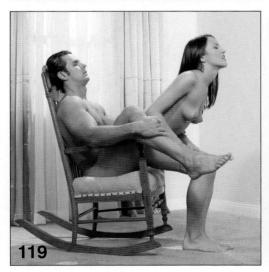

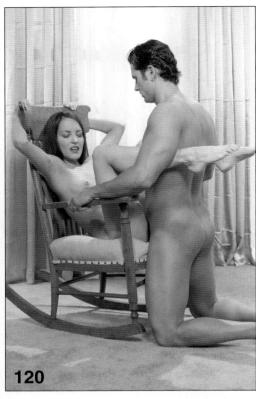

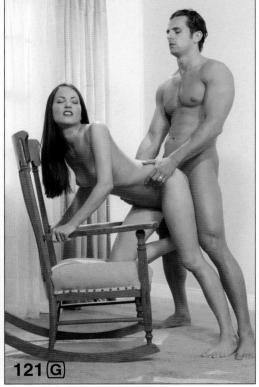

FOOTSTOOL

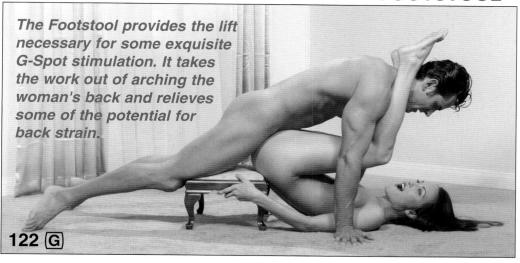

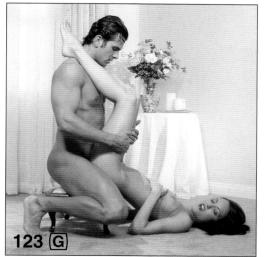

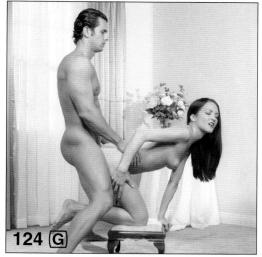

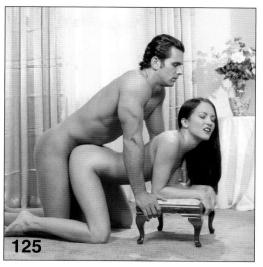

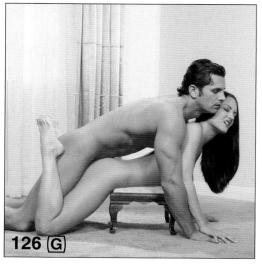

Oral Lovemaking A SENSUAL GUIDE TO ORAL SEX

or all our sophistication, we grown-ups haven't come all that far from the babies we once were, who put everything into their mouths to explore and experience. We still have the urge to taste the ones we love, literally as well as figuratively. And, unless you have tasted every part of your lover's body, you can't say you know him or her fully.

Think about your mouth for a minute: lips, tongue, teeth, breath. These elements can all be used while making oral love to your partner, as well as the head and facial hair and the nose and eyelashes; 'going down' with just your lips ignores a lot of good sexual resources. And there are other areas to make oral love to besides the genitals, so save them for last, after you've tasted other areas of the body.

The Body Eaters

Start with the most natural and accustomed oral contact-kissing your partner on the mouth. From there, it's a natural step to kissing other parts of the face, the throat and the ears. Lovers vary in how much force they can tolerate when someone blows into their ear, and you can actually do damage if you get carried away. It's best to begin, at least, by exhaling normally - sighing, really - into your lover's ear and combining that with light kisses and licking. Some people swear by prolonged tonguing in the ear - others, like me, find it makes them feel like they're underwater. As with everything else, start lightly, and slowly increase the intensity, observing your partner's response as you go. Don't wait for a clear negative signal; if what you're doing isn't building sexual tension, it's time to change to another kind of stimulation.

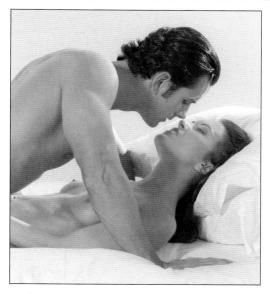

Continue your oral lovemaking down the body, front or back. If you concentrate on the front of the body, be sure to include unexpected areas like the armpits, as well as the breasts and pectoral area and the navel. Take advantage of the softness of the abdomen to really nuzzle and enjoy the fragrance of your lover's body.

'we still have the urge to taste the ones we love'

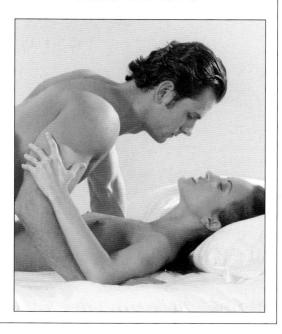

When you focus on the back, use your head hair, your facial hair, or your eyelashes to trail down the spine. The back of the neck is very sensitive, as is the area right at the small of the back, just before the crease of the buttocks begins. Many major nerves are concentrated in these two areas and the good feelings caused by a nimble tongue will spread in many directions.

Analingus

Note: Wash the anal area prior to any contact. Use a finger condom for digital insertion and an oral dam for oral stimulation.

Stimulating the anal area with your tongue is a separate and very erotic subject. If your lover seems squeamish about it, move away briefly, then try again very lightly. (For more on anal seduction and lovemaking, see Chapter 8). Continue tonguing the crease all the way down to the anus, spreading the

cheeks just enough (and very gently) to gain access.

You can do wonderfully delicate things to the anus with your tongue. Circle it with the tip of your tongue (rimming), alternating with trips up and down the crease. Linger over the ribbed texture of the circle of muscle around the anal opening. Even if you haven't yet tried inserting a finger into your lover's anus, you can easily probe with your tongue. The wetness of your tongue is a good lubricant. Little nips on the buttocks,

'don't wait for a strong negative signal before changing stimulation'

while you're in the area, contrast well with the softness of your tongue.

Fellatio

When you've explored his hard body thoroughly and are ready to concentrate on his penis, you'll feel his expectations build; he is eager to feel you sucking and to thrust his penis deep into your mouth.

But not just yet. Sure, sometimes you'll want to fellate him quickly without any teasing or elaborate buildup, but you should learn to create sexual suspense in this area of lovemaking, too. Breathe on his penis, let it get lost in your hair, and tickle his testicles before

you even begin to touch the shaft directly with your mouth, and then do so only lightly.

Slide your lips up and down his penis, then add your tongue – just the tip at first, lightly. Watch his reactions as you increase the pressure; some men won't be able to take much, either because they're too sensitive or because it makes them climax too fast. Then again, some men won't even feel what you're doing until you bear down.

For a change, try flicking the penis back and forth with your tongue. It's hard to describe, but

you should try to move the penis from side to side quickly with short strokes. As your tongue becomes a little dry, you'll get that cat's-tongue effect we talked about earlier, and the sheer unexpectedness will surprise and delight him.

Dip down to his testicles to give him a special treat. Light licking is very exciting, and if he trusts you, take a testicle slowly and gently into your mouth and caress it lightly with your tongue. The warmth is fantastic and the combination of sexual stimulation

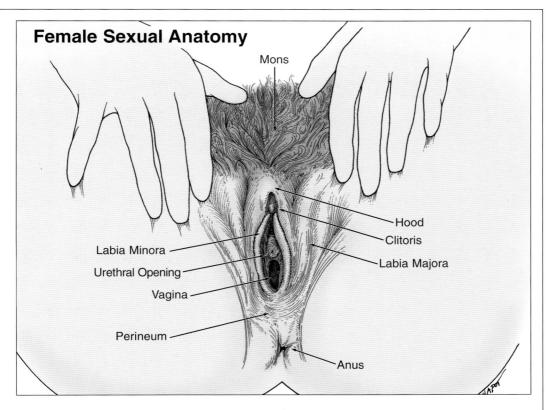

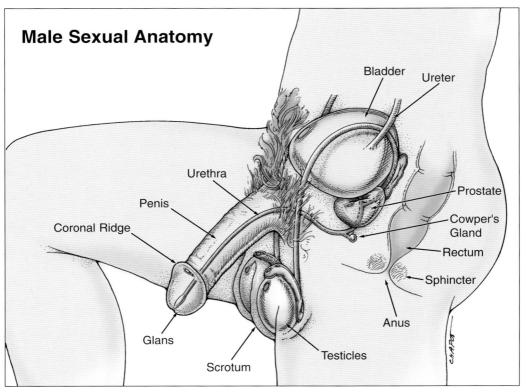

and danger can be very exciting for men.

Now move up to the crown and begin to take his penis in your mouth with just a little pressure, going deeper each time. If he's about to orgasm, and you haven't finished your playing yet, ease up or go back to stroking the underside for a while.

Many men will climax quickly after only a brief period of fellatio, but occasionally you'll meet a male with endurance who needs a lot of pressure to make him ejaculate. I get tired after a while-my upper lip gets sore from covering my teeth, and the muscles in my cheek ache from maintaining the pressure. If you're the same way, use your hands as a substitute while you just lick and wait for your mouth to recover.

If you want to provide him with friction as well as sucking pressure, tip the head of the penis up so that it rubs against the rough part of the hard palate.

Ejaculation

Women often worry about what to do with the semen when the man ejaculates—swallow it, spit it out, catch it in a handkerchief? If they haven't tasted it before, they worry about whether it will be awful, and if they have tasted it, and don't like it, they worry about how to dispose of it without slighting their man. The heroines of adult x-rated films always seem to love semen—they drink it in champagne glasses and rub it into their skin—so it's possible to be intimidated by all this and feel inadequate if you simply don't care for the stuff.

Relax. Most men I've talked to admit readily that they wouldn't take it in their mouth, given the chance. While they love it when a woman swallows the semen, especially because it permits them to enjoy their orgasm without interruption, they're often amazed that she agrees to do it and sometimes feel a little guilty at putting her through the experience.

If you're in a committed relationship, you owe it to yourself to try tasting semen at least once—though it can be somewhat acidic in composition. (If you have a sensitive stomach, drink some milk beforehand to coat the lining or some water afterward to dilute the ejaculate.) The taste varies from man to man and even from session to session with the same man, often because of what he's been eating or drinking. Some men have almost tasteless semen. And, as a rule, it tastes less

strong if the man has reached climax recently. It's wise to have a glass of water handy to help clear your throat.

And if you don't swallow it, don't make a big production out of it. It's not 'dirty', and you don't need to avoid contact with it. Always have a handkerchief or tissue available to spit into, and stay with him as he orgasms or he'll feel abandoned when you take him out of your mouth. Afterward, continue to suck and lick his penis gently as his erection softens, remembering that some men are extremely sensitive just after they've climaxed.

Cunnilingus

While women may feel nervous facing the business end of a formidable-looking penis,

men are just as often a little anxious about figuring out the complicated maze of hair, folds of skin, and mysterious hollows that constitute a woman's genitals. But, gentlemen, it's not that complicated, and if you're cautious, move slowly, and learn to associate what you do with how she reacts, you can become a master of the art.

One of the first things to deal with, even before you put tongue to clitoris, are her feelings about her vaginal area. She may be convinced that her genitals may be dirty and have an odor and she might be reluctant to let you pleasure her there – even if she loves fellating you. Corny as it may seem, it's up to you to reassure her; tell her that her vulva smells good, tastes good, and looks good. And if it doesn't smell or taste good, it's

worth a quick shower or bath together to be able to go down on her, even though it will delay your lovemaking for a short while. Instead of being offended that you suggested a shower, she'll be relieved that she's as clean as she can possibly be for you. (You'll be clean too, and that's no small consideration for a woman.) If an unpleasant odor and taste still persist, she may have an infection she doesn't know about. It's best to have that treated promptly.

Now that she's eager to have you taste her, begin by getting to know her vulva with your mouth. It's been described as a 'vertical smile' – turn your head and kiss it as you would her mouth. Touch the clitoris lightly with the tip of your tongue and explore the crevice between the inner and outer lips.

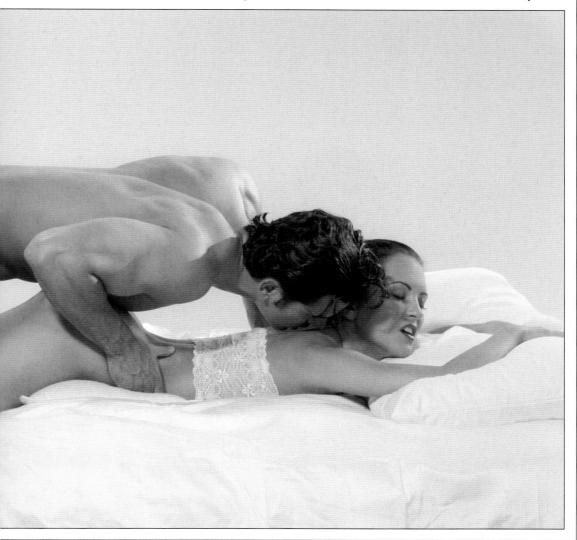

More often than not, a woman likes oral stimulation with very light pressure. With breast stimulation and intercourse, you can increase the pressure somewhat as she gets excited, but not with oral lovemaking. Too heavy a pressure will make her either sore or numb, and both are hard to remedy. To check yourself, watch to be sure that you're not putting too much pressure on her vulva.

Stroke down the labia with your tongue, come back up, circle the clitoris, then begin the cycle again. Alternate by flicking your tongue sideways across the vulva. If she responds markedly, do it again, whatever it was – but not harder! It's difficult not to intensify what you're doing when you know she likes it, but what she liked was what you were doing before. Take a detour down to the anus if you like, but remember: anything that's been inside the anus – hand, tongue, or penis – must be cleaned off before it's put in the vagina. Sorry, guys, but it's just not worth

her contracting an infection. (See Medical Precaution on page 91.)

You'll want to explore the inside of the vagina with your tongue, but keep in mind that there are fewer nerves deeper inside except for the Grafenberg Spot. Most of the nerves are clustered near the opening. A better option sometimes is to combine tonguework around the clitoris with a finger or two in the vagina.

Lighten up even more when she's about to climax. An oral orgasm is often delicate and elusive, and it can be obscured or even aborted by a sudden hard stroke. But if you know your woman, she'll find ways to tell you even more specifically what she likes – and ways to reward you for doing it!

After I reach orgasm with oral stimulation, I'm immediately ready to go again, but some women want to lie back and let the feeling taper off a bit first. Stay with her, in any case; she'll feel especially intimate with you at this juncture of your lovemaking.

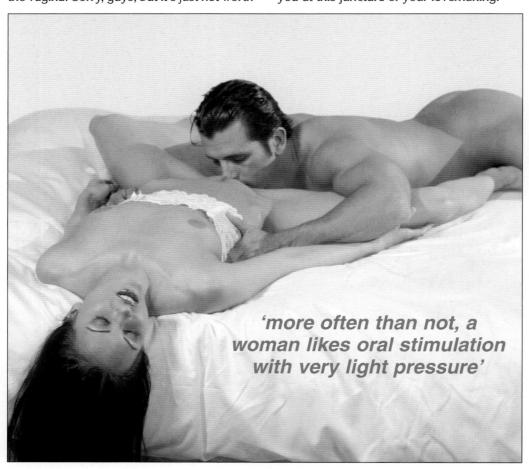

ORAL LOVEMAKING POSITIONS

POSITION	PAGE	NUMBERS
Cunnilingus	92	127-138
Fellatio	95	139-148

IMPORTANT MEDICAL PRECAUTION

 If you are not in a committed relationship, it is recommended that you use a dental dam when practicing cunnilingus or analingus. A piece of clear plastic wrap may be used, if necessary.

CUNNILINGUS

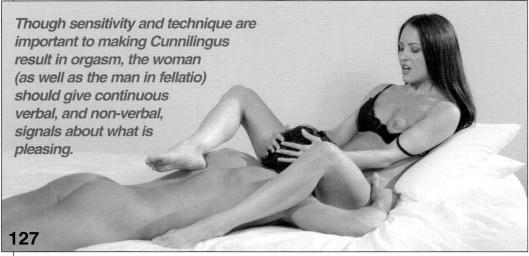

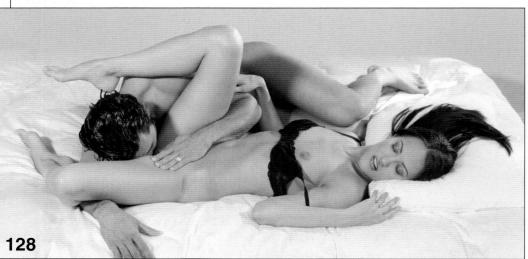

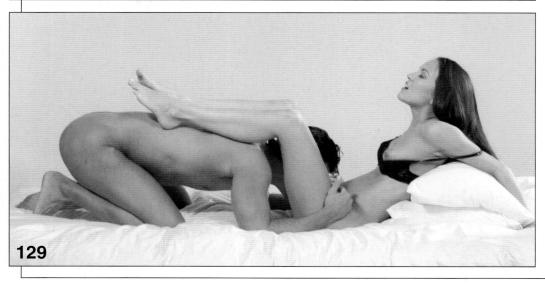

CUNNILINGUS-

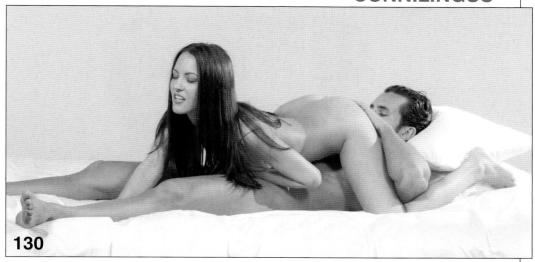

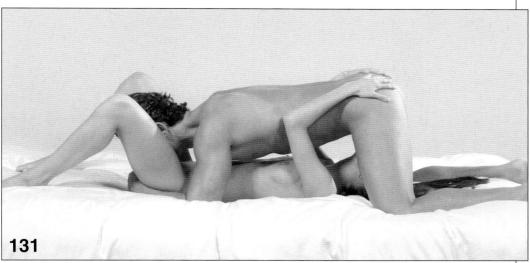

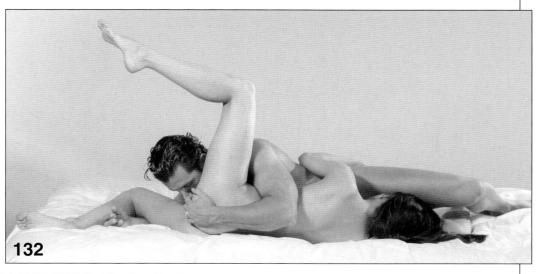

CUNNILINGUS

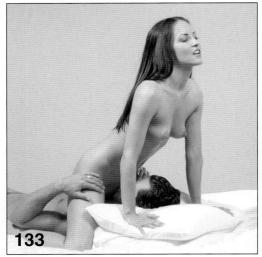

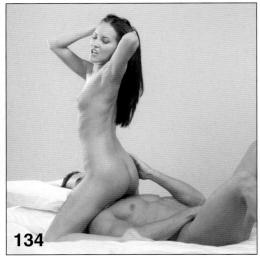

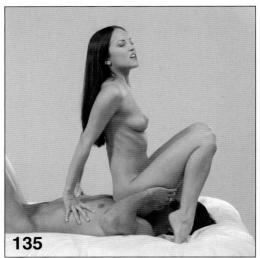

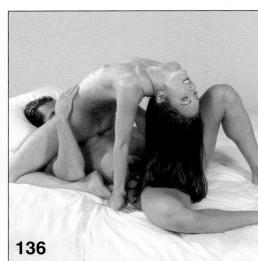

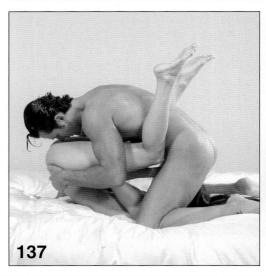

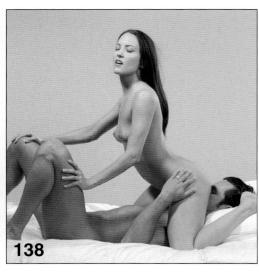

FELLATIO-

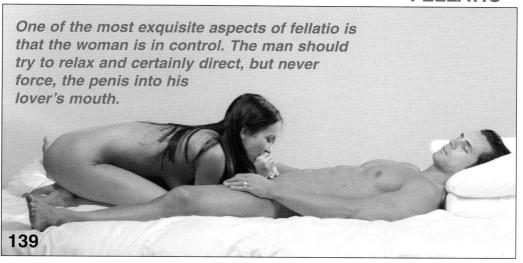

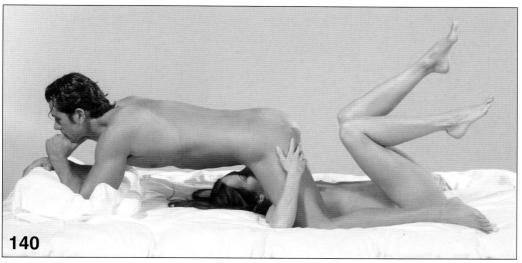

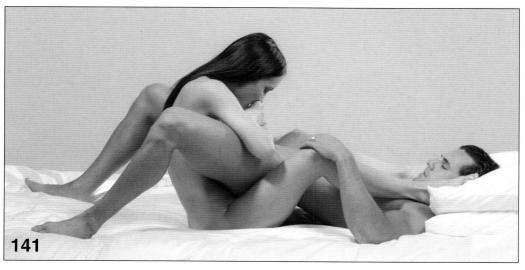

FELLATIO

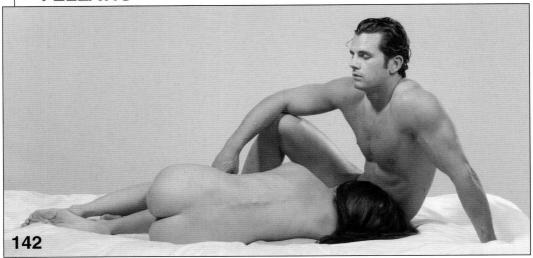

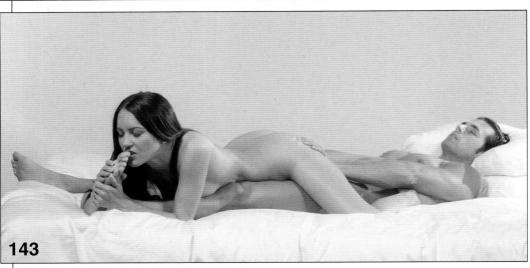

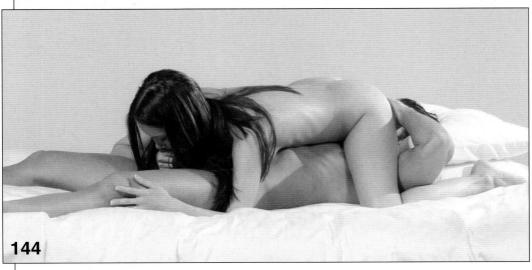

FELLATIO-

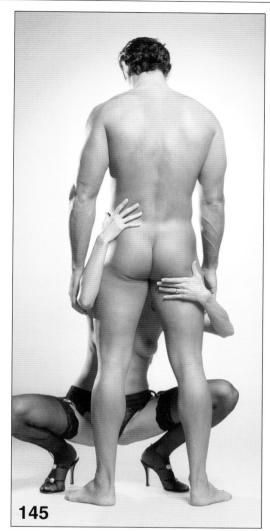

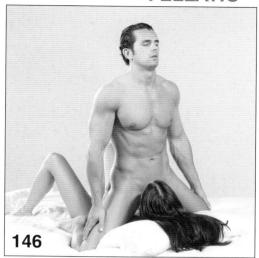

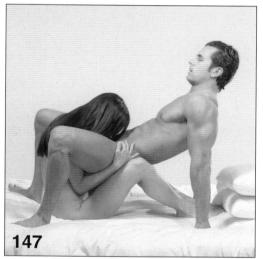

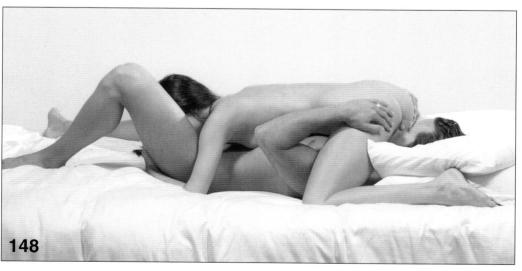

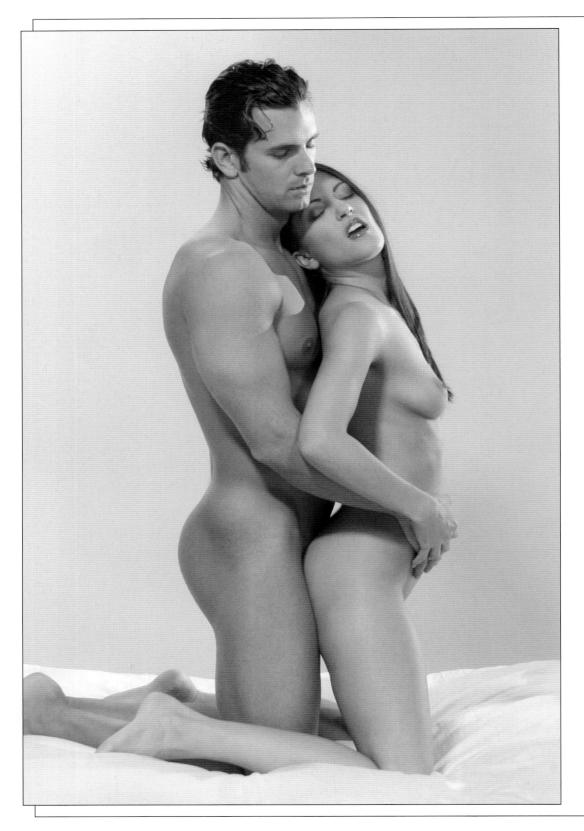

Anal Lovemaking THE PLEASURES OF ANAL SEX

alk about sexual suspense – for a protracted build-up, anal lovemaking has them all beat! Of all types of lovemaking (except those involving costumes, whips, etc.), anal sex requires the most mental and physical preparation. The rewards make it worthwhile, though, as you transcend a societal barrier to an unexplored range of sexual sensations, and discover a wonderful new type of sexual response in yourself and your lover.

'of all lovemaking, anal sex requires the most physical and mental preparation'

Seduction Techniques

We're all sensitive about our buttocks, as well we should be. Phrases like 'cover your ass' can illustrate our feeling of vulnerability there. Overcoming this fear and the taboos about anal contact (think about the religious and legal connotations of the word 'sodomy', for example) can be a big mental and physical effort for us. But, at the same time, our sensitivity can enable us to experience erotic pleasure by gentle stimulation around and in the anus. And knowing that you've conquered one of society's most ancient taboos can give you satisfaction, by itself.

The fact that you are reading this chapter means you have a curiosity to explore anal sex, but what about your partner? In my experience, women rarely have trouble convincing their men to experiment anally. First of all, men are often more sensitive than women

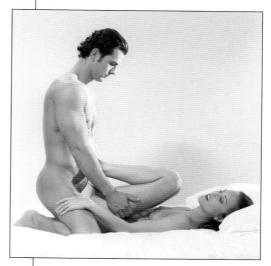

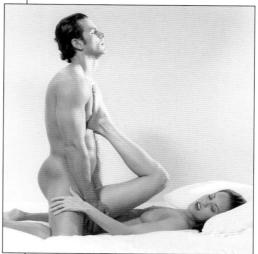

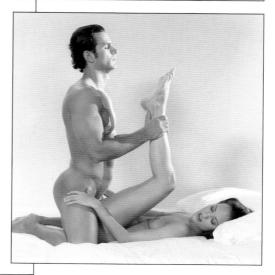

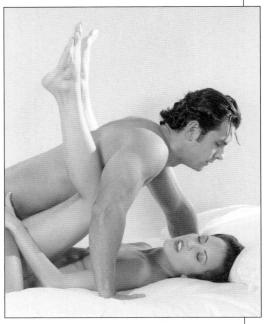

around the anus because of its proximity to the prostate (a real nerve center in the pelvic area), and the pleasure they can receive is enough by itself to overcome any squeamishness they might have at being touched and probed there. Most men assume that women are equally sensitive. Second, men can find anal intercourse very stimulating because of the tight fit.

A Woman's Concerns

So, the task is usually to convince the woman. And what is she worried about? First and foremost, that probing the anus will hurt; second, that the experience will involve contact with fecal matter and be unsanitary; and third, that anal intercourse indicates something shameful, or bestial, about her, and /or her man. If you follow these instructions, however, you won't cause her any pain that she doesn't willingly accept (and when you're first experimenting, a small twinge or two is virtually unavoidable), and cleanliness

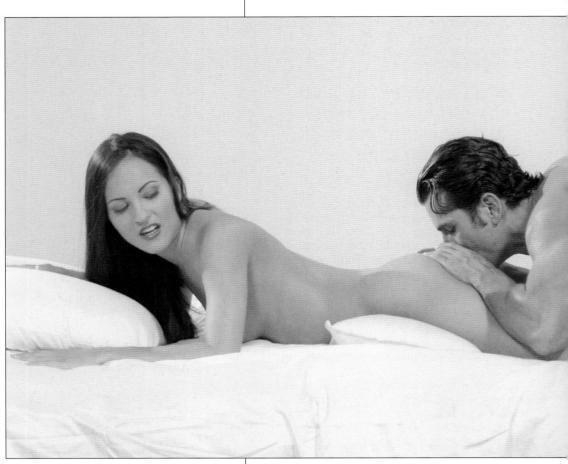

won't be a worry. As far as your feeling about the act itself goes, the sexual motivation varies between each male and female.

Gentlemen, you can, of course, sit your lover down and explain why you want to make anal love to her. If she's alarmed, assure her that she will control everything and that you'll never force her. And if she insists that she's not sensitive around the anus and won't enjoy it, remind her of the Grafenberg Spot. The connection between urination and stimulation of the Grafenberg Spot has kept many women from experiencing orgasms based in the vagina. The connection between anal intercourse and defecation often keeps them from enjoying anal

'try mixing anal stimulation with the rest of your usual lovemaking'

contact. Once the association between certain nerves and elimination is seen for what it is—just an association—a woman can enjoy the stimulation for its own sake. It's not in the least 'shameful' or 'bestial' to enjoy anal stimulation.

However, words and arguments are often inadequate when it comes to sex. A better way may be to seduce your lover without very much conversation at all. Those women, in particular, who insist they have no pleasant anal sensations are often amenable to some indirect persuasion.

Start with a massage, working down the back and kneading her buttocks. She may contract her muscles out of anxiety, but if you continue as if there were nothing special about it, she'll relax and begin to enjoy the caress of your hands. Dip down into the crease, now and then, but be brief; you can alarm her by going too fast. The first few times you try this, stop before she gets anxious. Her memories will be of non-threatening, erotic sensations; she'll miss your hand and want it back. The next time, she'll accept more and longer stimulation. Over the course of several lovemaking sessions, progress until you can caress the outside of the anus without arousing any anxiety in her.

Lubricant & Condoms

At this point in your explorations, you should have a water-based lubricant and finger condoms ready. The rectum has a small supply of its own internal mucus to help smooth the way, but it isn't enough to ease insertion and isn't of the proper consistency. Use lubrication generously with anything that's inserted in the anus.

Now, with the tip of your little finger (use a finger condom and be sure your fingernail is clipped), press inward, just a little. She may squeeze around your finger and tense up, but proceed as you did before, trying a little at a time, mixing anal stimulation with all the rest of your usual lovemaking.

When you're able to insert your finger farther, hold it still rather than thrusting back and forth—no matter how relaxed she is, thrusting can hurt, and when you get to actual intercourse, you'll see that the sensations are so intense that a lot of thrusting isn't necessary for maximum pleasure. Soon you'll be able to insert a larger finger with her consent.

By this time, all but the most shy women

will have commented about what you're doing. This is your opportunity to reassure her about the naturalness and sexiness of anal intercourse and it's very important to make sure she's comfortable before you proceed.

Her second fear—the one about cleanliness—is also important here. It's really no problem; if she's had a bowel movement anytime recently and is in reasonably good digestive health, there's nothing either of you will encounter in the rectum that will embarrass her. Even so, it's best to wear a condom

'it is not in the least shameful to enjoy anal stimulation'

change to a fresh one), and continue your intercourse in the regular way.

If you've been gentle, she'll want to try it again and this time she'll be more relaxed. You won't have to move much at all once you're in – the tightness and the overwhelming excitement will be enough to bring you to

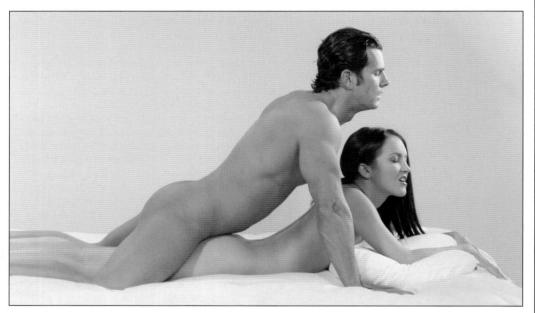

just to make both of you feel better, and dispose of it discreetly.

When she's comfortable, arrange yourselves in a standard rear-entry position and explore her with your finger the way you have already been doing, using another finger to stroke her vagina at the same time. (Be careful not to interchange the two fingers.*) When you feel her sphincter relax. put your penis up against her anus and push very gently. It won't go in directly, of course; let her push back now, as much as she wants to. Caress and reassure her continually. She should control the insertion totally-you can't possibly gauge how it feels to her yourself, so you should rely on her reactions to guide you. You might not even get in very far the first time-it could hurt more than she expected or maybe she just gets scared. In that case, simply remove the condom (or

climax. She may orgasm just from the anal stimulation—it's the feeling of **fullness** that is so arousing for her—but it can help to combine it with a skillful finger or two around the clitoris and vagina.

Once you've reached orgasm, withdraw from her slowly and carefully. Stay with her as she comes down and share your pride with her that the two of you have transcended taboos and your own concerns. Even if you don't try anal intercourse very often (and many people do it just once, to see what it's like and to show that they can), you've advanced your intimacy and your mutual daring beyond another sexual plateau.

*Note: Due to the different biological nature of the rectum and vagina, do not ever insert anything (vibrator, penis, finger, etc.) into the vagina that has been in the rectum, without first carefully washing it.

ANAL LOVEMAKING POSITIONS

POSITION

PAGE

NUMBERS

Anal Entry

104

149-156

IMPORTANT MEDICAL PRECAUTIONS

- The rectal sphincter is extremely sensitive and should be stimulated with the utmost care. The rectum has a small supply of its own internal mucus, but it is not enough to ease insertion and properly lubricate intercourse. Apply a liberal amount of water-based lubricant to the anus before inserting anything.
- Always use a condom or finger condoms on anything inserted into the anus (including sex toys).
- Due to the different biological nature of the rectum and vagina, do not ever insert anything (vibrator, penis, finger, etc.) into the vagina that has been in the rectum without first carefully washing it.
- If you are not in a committed relationship, it is recommended that you use a dental dam when practicing analingus. A piece of clear plastic wrap may be used, if necessary.

ANAL ENTRY-

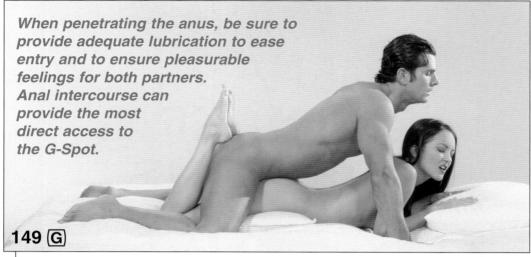

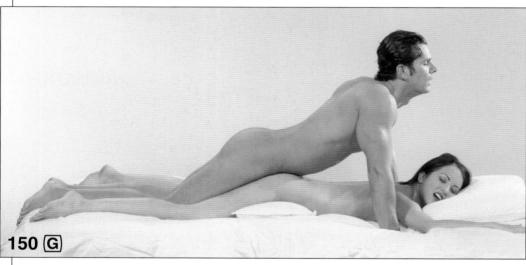

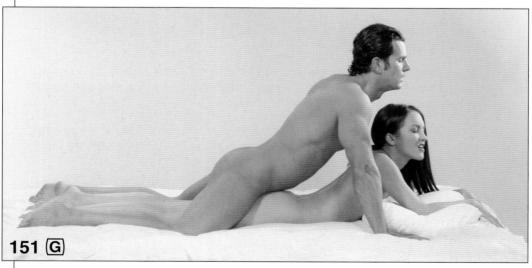

ANAL ENTRY-

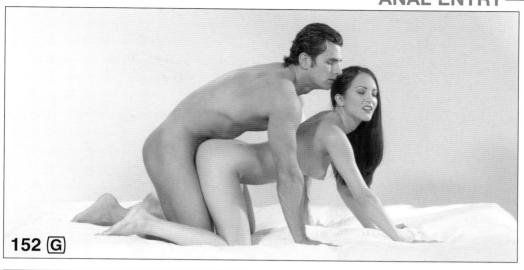

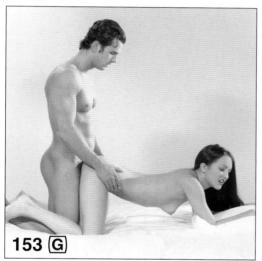

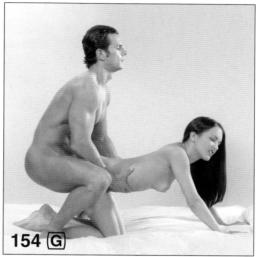

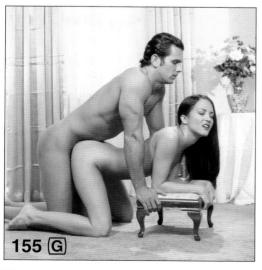

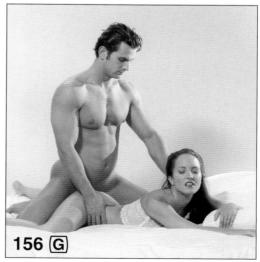

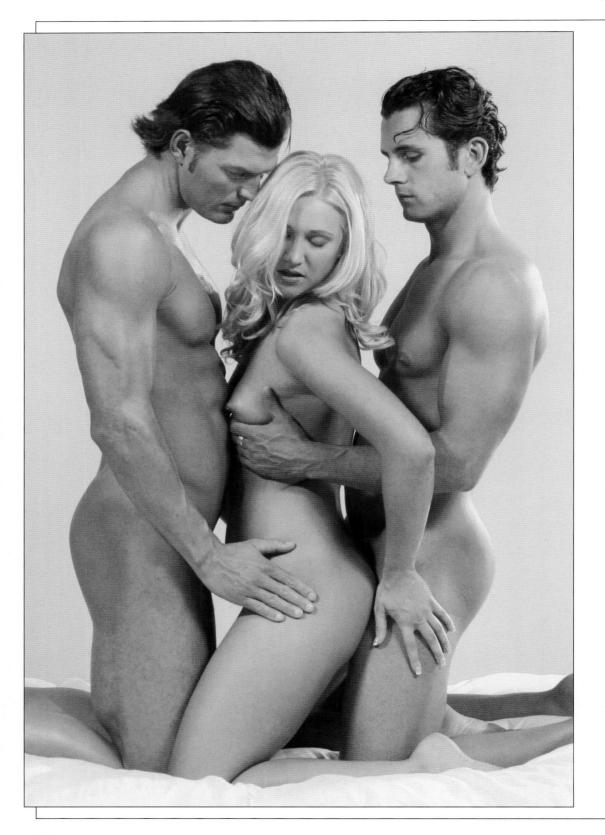

Advanced Studies

THE ETIQUETTE OF MULTIPLE PARTNERS

ooner or later, many of us wonder about sexual variations that go beyond the conventional, particularly those that transcend the usual rules about privacy during lovemaking. The appeal of something like a threesome. for example, has many aspects: the thrill of more than one person paying attention to you at one time, the possibility of experimenting with bisexuality in a non-threatening situation, a bit of exhibitionism (not the trenchcoat variety, but a healthy desire to show off what you do well), and voyeurism (again, not Peeping Tomism, but a natural curiosity to watch other people make love). A successful orgy will satisfy all those desires, plus giving you one fantastic orgasm (or two!).

'sooner or later many of us wonder about sexual variations'

Threesomes

There's no shortage of ideas on what to do once you've gotten your fantasy group into a compromising situation, but how do you get them there in the first place? You can just ask them directly, of course, but it takes a lot of courage for them to say yes. But other forms of 'asking' may not be as difficult as you think. Any excuse for physical contact can be the start of something bigger.

One of my favorites is a two-on-one massage. It's easy to find a reason for this: massage is tiring and becomes easier if two people do it, and the masseurs, or masseuses, can teach each other new strokes, demonstrating on each other, if necessary. Any good massage book will

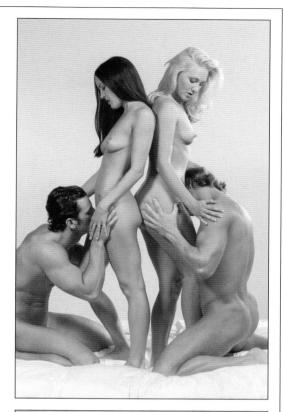

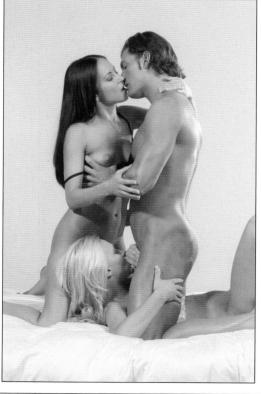

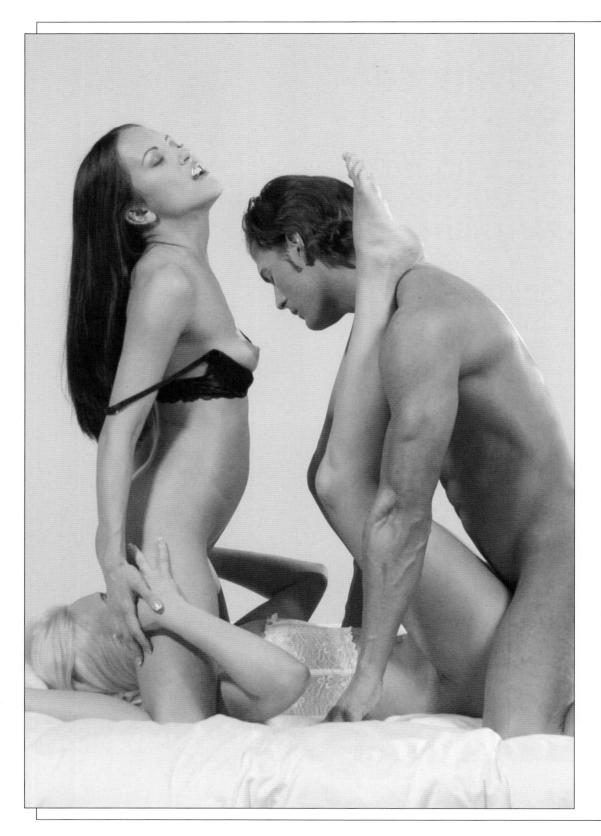

tell you that massage should properly be done in the nude, and while you may not be able to persuade everyone to strip naked, you can usually get them to at least bare themselves to the waist. Picture the scene: two women, nude from the waist up, leaning over a man lying on his stomach, rubbing scented oil into his back.

Now if that doesn't give rise to some erotic fantasies on everyone's part, I don't know what will!

All right, so you've set the scene; everyone's breathing a little heavier and trying to conceal their thoughts. Who makes the first move? Often, there is no 'first move', as such. The strokes get a little firmer and more intimate; his pants go down as you cover a larger area of his the back. masseuses move each other's hands to show how to do a stroke, and before you know it, everyone's tangled on the floor together feeling daring. No one wants to say anything for fear that this lovely dream will come to an end.

Other 'innocent' situations include cuddling up to each other 'for warmth' on a cold night while watching TV, or on a camping trip, skinny-dip-

ping at night (it's hard to tell who's doing what to whom under the water), tickle-fights, strip poker—anything that gives you the excuse either to touch each other or to remove clothing, or both. It's up to you to gauge whether there's a three-way attraction, of course; but if you're reasonably sure, then a premise is all that's needed. Don't rely on alcohol or drugs to loosen inhibitions, however—sleeping together may be literally all you do.

Etiquette

Because threesomes are a new erotic experience for most people, you have to take special care to be sure that no one feels uncomfortable. If you're lucky enough to have a true three-way encounter, with the

'in a threesome, two of you know each other better than you do the third'

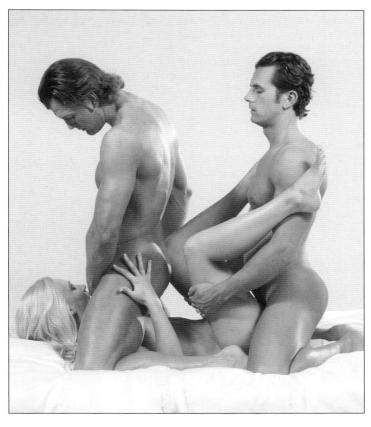

two people of the same gender relating to each other sexually, as well as to the one of the opposite sex, then the attention tends to divide itself equally, so no one feels left out. If it's more of a two-on-one situation, be sure to keep an eye out for the third lover. It always happens that two of you know each other better than you do the third, and that person is likely to feel excluded from the triad if you're not careful. This doesn't mean that all of you have to have simultaneous orgasms or always relate sexually to the other two at the same time; however, one of the pleasures of threesomes is that there are other, more indirect types of enjoyment.

Voyeurism

Watching other people make love is a

pleasure in its own right. It satisfies our curiosity, teaches us things, and arouses us. If you need a rest or just feel like watching at some point, let the other two make love while you lie back and observe.

People often feel that they must look silly while making love, but you'll see, as you watch, that this just isn't so; human bodies fit together beautifully, and the sight of skin sliding against skin (slightly damp from perspiration and gleaming in the light) is very provocative. Look at the reactions of your partners: the curled toes, the tensed thighs, the expressions of almost-pain, and then release of tension, that pass over their faces.

You'll also learn a lot from watching. You may find your usual partner, for example, reacting to types of stimulation that you did not know he or she liked, and you'll know exactly how to duplicate the sensation when you get the chance. You'll get a sense of other people's rhythms, and you may see some tricks you didn't know about before.

'a ménage a trois is a unique opportunity to experiment'

Inevitably, you'll be so aroused by what you see that you'll want to participate. This can be tricky—how do you know whether you're intruding or not, and how much can you get involved without detracting from what they're doing? As in everything else, start slowly. Reach over and stroke someone gently—watch to see if your touch registers (if they're really involved, they may not even feel what you're doing). If it does register, move in a little closer.

A really active threesome is a fluid experience—twos become threes and go back to twos again—and you're only expected to participate whenever it feels right. But especially if you've never tried voyeurism before, you may want to stay back and watch the event through to its completion just out of curiosity, and that's fine too—you'll get your turn in a little while.

Exhibitionism

The flip side of voyeurism is exhibitionism—and while it doesn't necessaily have to involve 'showing off', in the usual sense, there's always an element of that occurring. And why not? You're a good lover and an attractive person, and there's no reason to hide your talents. Sex is one of the many things you do well, and if the right opportunity to demonstrate comes up, let it show.

Thinking about it out of context, you might assume that you could never lose your self-consciousness enough to actually make love in front of someone else, espe-

cially your own lover. But, in the right situation, with people you trust, and an unbearable level of sexual tension in the air, you may feel differently. Part of the time, you'll actually forget there's another person watching, believe it or not – especially when you're near orgasm. And the other part of the time, you'll have a curious double sensation of both participating in your own

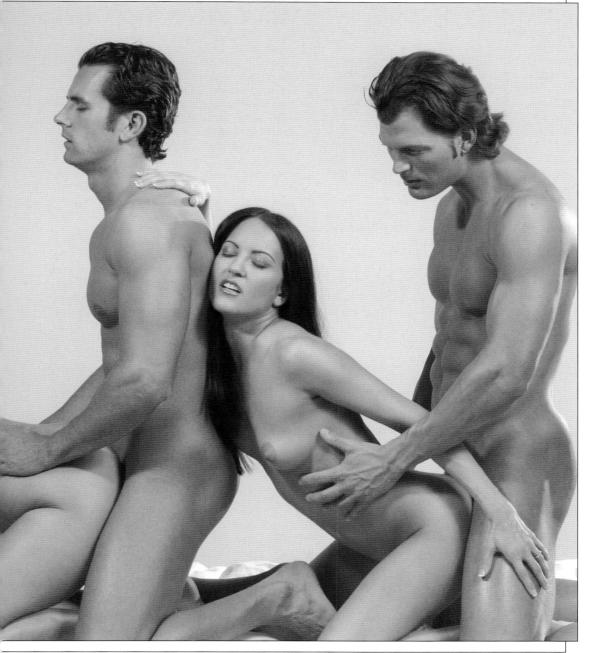

lovemaking and also imagining watching yourself from the outside.

Whenever it feels right, reach over and bring the third party into the lovemaking, using whatever part of your body is free at the moment. He or she might just be waiting for an opportunity to get in on the action. And because people are shy about voicing their needs in a totally new situation, you need to be especially sensitive, and anticipate what they want.

Bisexuality

One of the elements that is potentially most exciting—and most disquieting—in a ménage a trois, is the opportunity to experiment with a little bisexuality. Almost all of us have wondered (at least once) what it might be like to have some contact with a lover of the same sex, but opportunities to try it out one-on-one are not too frequent; a perfect place to experiment is a threesome. In that situation, a hand or mouth can 'inadvertently' land on a lover of the same sex; if the contact feels good, you can pursue it, and if it seems to be a wrong move, you can switch back to heterosexual sex without feeling embarrassed or rejected.

Regardless of how you and the same-sex partner feel about the experience, neither of you have automatically become gay just by virtue of having had sexual contact. If you choose to pursue same-sex encounters, or even have them exclusively, that's another story, but a little experimentation is just that,

and means only that you have the same bisexual tendencies that almost all of us do to one degree or another.

If the same-sex contact does feel good, you should take it as far as you feel comfortable. Don't worry about what other people do with each other-whatever you feel good doing is what you should do. Think of the advantages you have as a member of the same sex: you know from personal experience what feels good, and you know what reactions to watch for to indicate whether your efforts are producing the effect you had in mind. You can also be instrumental in teaching the partner of the opposite sex some things about the two of you; as we know, there's a limit to what can be described in words-some things just have to be demonstrated! And, finally, don't worry about alarming the lover of the opposite sex, who will, without a doubt, be fascinated and highly aroused. Watching women make love is one of the favorite fantasies of many men-look at popular adult films for evidence – and I know I'm intrigued at the idea of watching two men engage each other erotically.

If you have never indulged many of your fantasies before, a threesome is the place to do it. By its very definition, it's out of the sexual mainstream, and that automatically gives you new freedoms. Take advantage, test a pet theory or two, touch everything, and everyone, and be open to being touched in new ways.

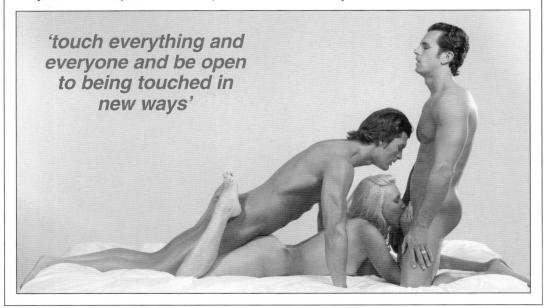

MULTIPLE PARTNER POSITIONS

POSITION	PAGE	NUMBERS
Threesome (2M/1F)	114	157-164
Threesome (1M/2F)	116	165-173
Foursome (2M/2F)	118	174-178

IMPORTANT MEDICAL PRECAUTIONS

- Due to the introduction of person(s) outside of a committed relationship, it is recommended that a condom be used for all sexual acts, including vaginal and anal entry and fellatio. Use a dental dam when practicing cunnilingus or analingus. A clear piece of plastic wrap may be used, if necessary.
- Always use a condom or finger condoms on anything inserted into the anus (including sex toys).
- Due to the different biological nature of the rectum and vagina, do not ever insert anything (vibrator, penis, finger, etc.) into the vagina that has been in the rectum without first carefully washing it.
- The rectal sphincter is extremely sensitive and should be stimulated with the utmost care. The rectum has a small supply of its own internal mucus, but it is not enough to ease insertion and properly lubricate intercourse. Apply a liberal amount of water-based lubricant to the anus before inserting anything.

THREESOME (2M/1F)

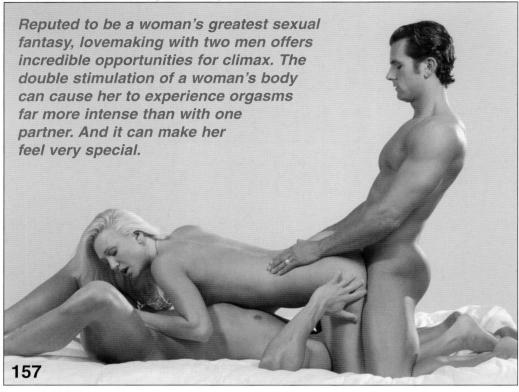

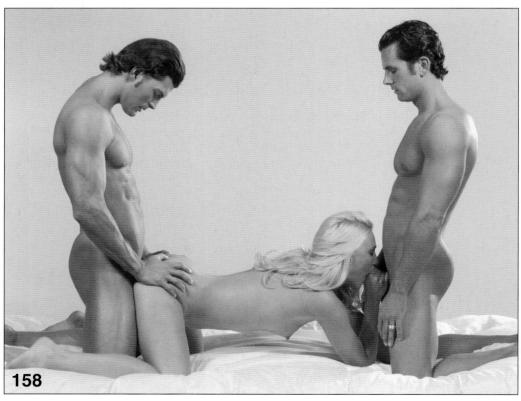

-THREESOME (2M/1F)-

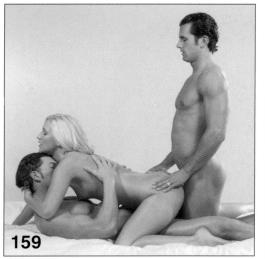

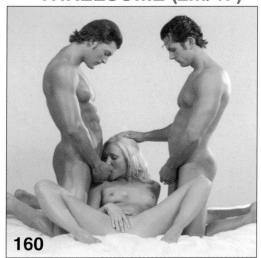

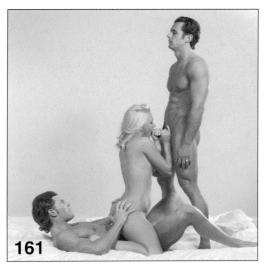

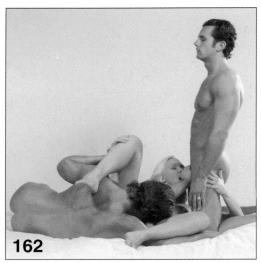

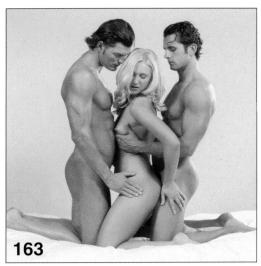

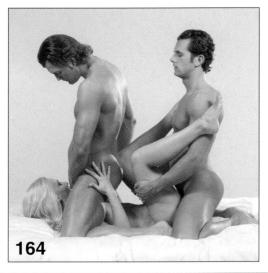

THREESOME (1M/2F)

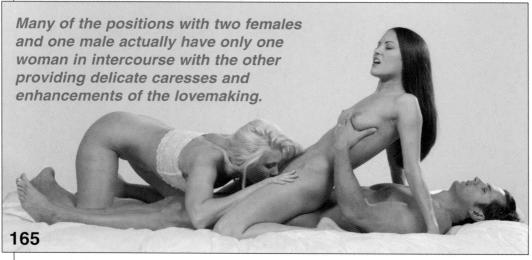

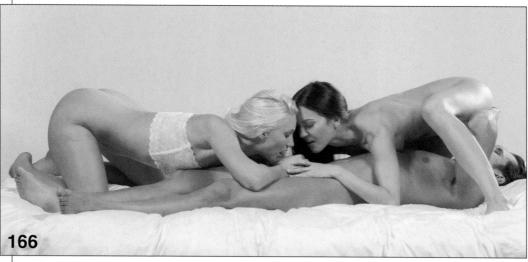

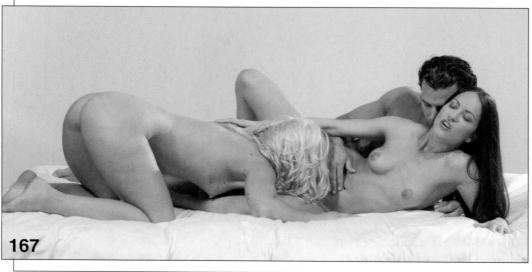

-THREESOME (1M/2F)-

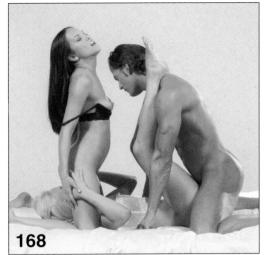

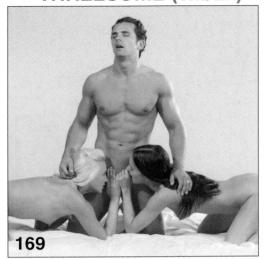

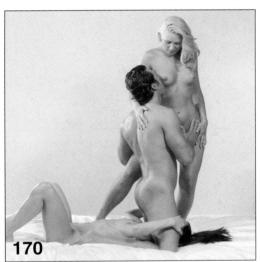

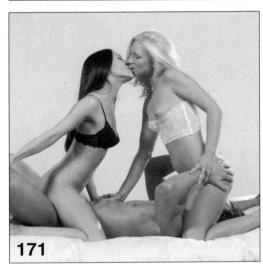

FOURSOME (2M/2F)

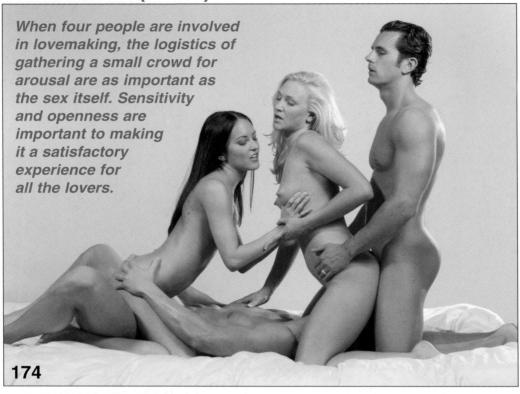

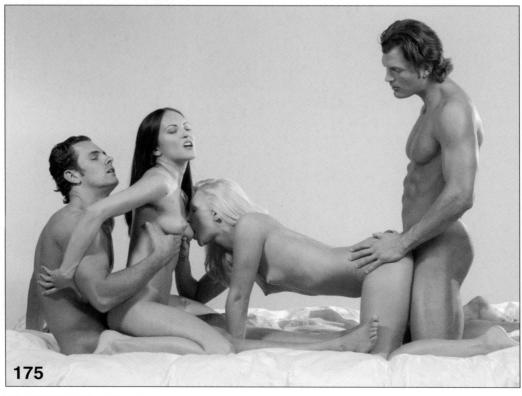

-FOURSOME (2M/2F)-

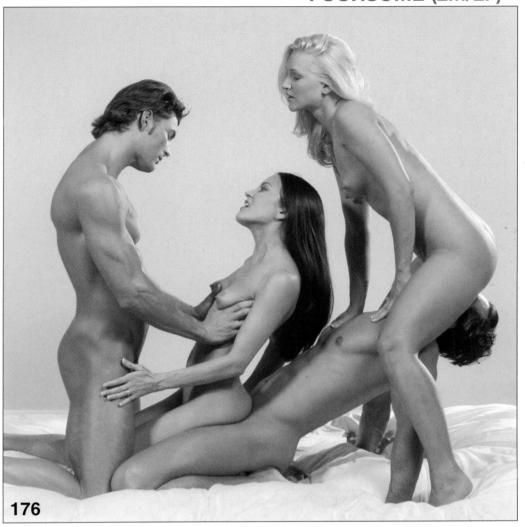

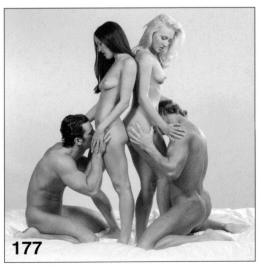

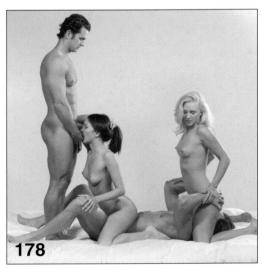

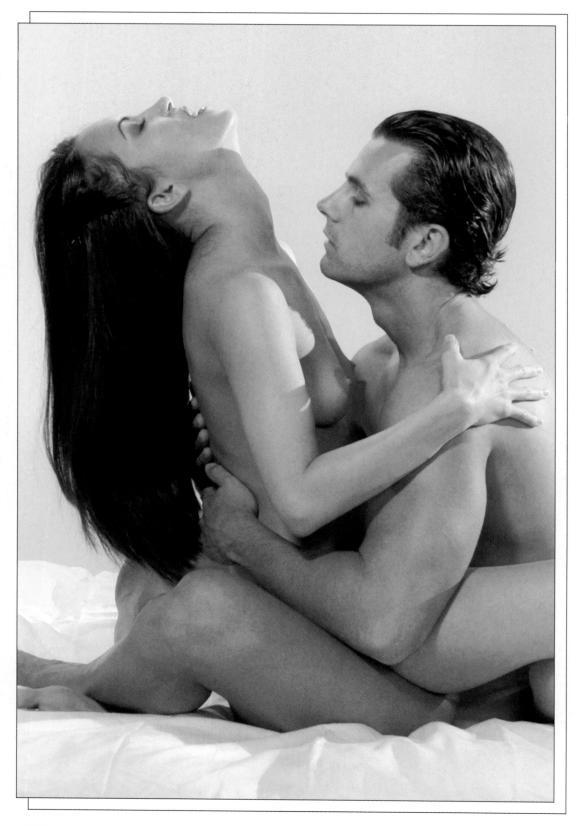

POSITIONS INDEX AN INDEX OF ALL POSITIONS

CATEGORY	PAGE	NUMBERS
VAGINAL ENTRY POSITIONS		
Male Superior (Missionary)	52	1-21
Side-by-Side	58	22-29
Female Superior (Facing)	61	30-42
Male Superior (Opposing/Rear Entry)	65	43-47
Female Superior (Opposing)	66	48-54
Sitting & Squatting (Facing)	68	55-65
Sitting & Squatting (Opposing)	70	66-69
Standing	71	70 - 77
Kneeling	73	78-82
Edge of Bed	74	83-98
Wing Back Chair	77	99-107
Armless Chair	79	108-114
Rocking Chair	81	115-121
Footstool	83	122-126
ORAL LOVEMAKING POSITIONS		
Cunnilingus	92	127-138
Fellatio	95	139-148
ANAL LOVENAKING POSITIONS		
ANAL LOVEMAKING POSITIONS Anal Entry	104	140 150
Ariai Liniiy	104	149-156
MULTIPLE PARTNER POSITIONS		
Threesome (2M/1F)	114	157-164
Threesome (1M/2F)	116	165-173
Foursome (2M/2F)	118	174-178

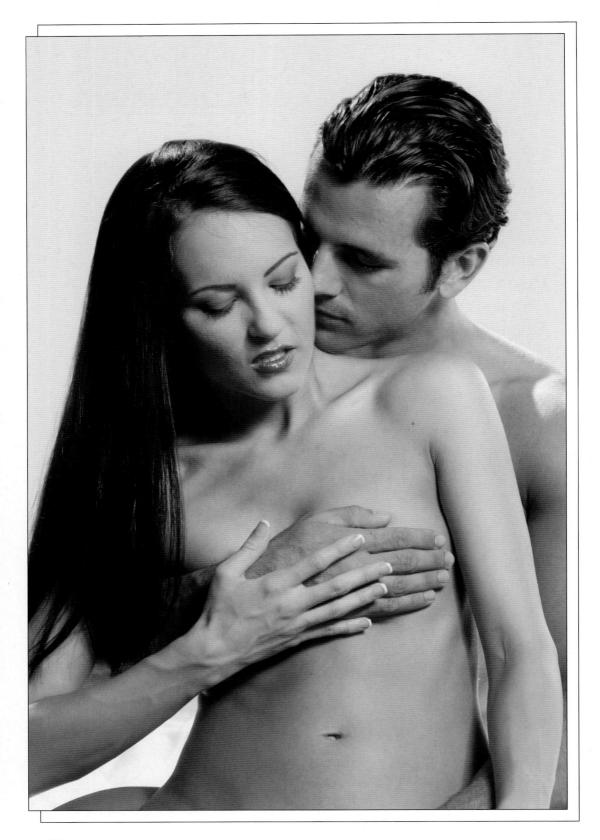

GLOSSARY A DICTIONARY OF LOVEMAKING TERMS

Α

Abstinence To refrain from having sex.

Age of Consent The age at which a person is legally deemed to be capable of giving consent to sexual intercourse.

AIDS (Acquired Immune Deficiency Syndrome) A condition caused by the Human Immunodeficiency Virus (HIV) in which the body loses its ability to defend itself against illness.

Anal Intercourse A form of sexual intercourse (either heterosexual or homosexual) in which a man inserts his penis into his partner's anus.

Analingus Using the mouth or tongue to stimulate the anal area.

Anus The excretory opening at the end of the rectum.

Aphrodisiac A substance such as a food or drink that is alleged to increase sexual desire.

Areola The lightly pigmented area around the human nipple, which swells slightly at times of sexual arousal.

Arousal Changes to the body, due to physical and mental stimuli, which prepare it for intercourse.

Asymptomatic Having no symptoms. Some sexually transmitted diseases, such as chlamydia, are asymptomatic.

F

Bartholin's Glands Two tiny ducts located on either side of the vaginal entrance that secrete fluid during sexual arousal.

Bestial Sexual activity between a person and an animal.

Bisexual(ity) Being sexually attracted to people of both sexes and/or having sexual relations with them.

Blow Job Slang term for fellatio.

Bodily Fluids Blood, semen, vaginal secretions, urine, feces, saliva and tears.

Bondage & Discipline (B&D) Sexual activity in which one partner is bound while the other 'disciplines' them by spanking and/or whipping.

C

Carnal Knowledge Sexual intercourse.

Celibacy A state of abstinence from sexual intercourse.

Cervix The neck of the uterus; it connects the uterus with the vagina.

Chancre A primary syphilitic lesion resembling a sore with a hard base.

Chastity Voluntary abstinence from sexual activity.

Chlamydia A sexually transmitted disease caused by a bacterium.

Circumcision A surgical procedure to remove the foreskin of the penis.

Climax The point during sexual activity when orgasm is reached.

Clitoris The small, nose-shaped organ at the top of the small lips of a woman's vulva. It becomes erect when the woman is sexually stimulated and, because it contains many nerve endings, is very sensitive to touch and plays a large part in female orgasm.

Coitus Sexual intercourse.

Condom A thin sheath placed over the erect penis before sexual intercourse to prevent pregnancy and to protect from sexually transmitted diseases; a female condom is a soft pouch that is inserted into the vagina before intercourse.

Copulation Sexual intercourse.

Corona The sensitive rim of tissue between the glans and the shaft of the penis.

Coronal Ridge The ridge on the penis where the glans curves in to join the shaft.

Cowper's Glands Below the prostate, a pair

of small glands which secrete clear fluid into the urethra prior to ejaculation.

Cunnilingus A form of oral sex in which the tongue or mouth is used to stimulate the vulva of a woman.

Cystitis Inflammation of the bladder caused by a bacterial infection.

Γ

Defecation The act of eliminating waste from the digestive tract, or emptying the bowel.

Deflowering Slang for breaking the hymen during initial intercourse.

Diaphragm A saucer shaped flexible contraceptive device that is filled with spermicide and inserted into the vagina to block the cervical opening and prevent fertilization.

Dominatrix A female who acts out the role of dominating her partner during sex.

F

Ejaculate To have an orgasm with the ejection of semen from the penis. Also, the product of ejaculation.

Endocrine Glands The glands that produce hormones and secrete them into the blood-stream. They include the testicles and the ovaries.

Erect, Erection The swelling and stiffening of the penis, clitoris, or nipples during sexual stimulation.

Erogenous Zone Breasts and genitals or any area of the body that is sensitive to sexual stimulation.

Erotic Concerning or arousing sexual desire or pleasure.

Exhibitionism Exposing the genitals for the purpose of sexual arousal and gratification.

F

Fallopian Tube The tubes that connect the ovaries with the uterus.

Fantasy In sexual terms, imagining sexual situations or events involving real, or imaginary, people and/or situations.

Fellatio A form of oral sex in which the tongue or mouth is used to stimulate the penis.

Foreplay Sexual activity, including kissing and fondling, that provides stimulation prior to actual intercourse.

Foreskin The retractable sheath of skin cov-

ering the tip of the penis, often removed by circumcision.

G

G-Spot An alternate term for the Grafenberg Spot.

Gay Male homosexual.

Genital Herpes A sexually transmitted disease caused by the herpes simplex virus.

Genitals The external sex organs: a man's penis and testicles; a woman's labia, clitoris, and vagina.

Glans The rounded, cone-shaped head of the penis.

Gonorrhea A sexually transmitted disease caused by a bacterium.

Grafenberg Spot A small area within the vagina that is especially responsive to stimulation.

Group Sex A number of people indulging in various sexual activities with each other at the same time; orgy.

Н

Hand Job Slang term for manual stimulation of the genitals by a partner.

Hepatitis A group of viruses that cause liver disease. Vaccines are available for HAV and HBV, both of which may be transmitted by sexual contact.

Heterosexual A person who is primarily sexually attracted to people of the opposite sex.

HIV Human Immunodeficiency Virus, the virus that causes AIDS.

Homosexual A person who is primarily sexually attracted to people of the same sex.

Hymen A thin membrane present at birth that partially covers the entrance to the vagina. Once thought to be proof of virginity, the hymen may be broken by many activities other than sexual intercourse.

I

Impotence Commonly used term for erectile dysfunction, or lack of penile erections.

Intercourse Sexual activity in which the penis is inserted into an orifice. The term is often modified accordingly, e.g. anal intercourse.

K

Kegel Exercises Exercises for men or women designed to increase control of the

PC (pubococcygeus) muscles, to increase sexual awareness and pleasure.

I

Labia The lips of the female genitals. The small inner lips are called the labia minora, and the large outer lips the labia majora.

Lesbian A female homosexual.

Libido A measure of sexual energy.

Lubricant A fluid either secreted from the vaginal walls or produced synthetically to supplement or replace natural lubrication during sexual activity. Water-based lubricant is required for anal intercourse with a condom.

Lust A strong sexual urge or desire.

M

Masturbation The stimulation of one's own sexual organs, usually to achieve orgasm.

Ménage a Trois (French) A group of three. Usually used to describe a sexual relationship between three people.

Menopause The period in a woman's life when menstruation ceases.

Menstruation The monthly discharge of endometrium that takes place if no fertilized ovum (egg) is implanted.

Missionary Position The most common sexual position; face to face with the male on top.

Mons The mound of fatty tissue buffering the pubic bone; mons pubis, mons veneris.

Multiple Orgasms Having more than one orgasm during a single session of intercourse.

Mutual Masturbation When partners stimulate each other's sexual organs.

N

Nipple The darkened area at the tip of the breast in both men and women. Sensitive to sexual stimulation in both sexes.

Nocturnal Emission Involuntary male orgasm during sleep.

NSU Non-specific urethritis, caused by a bacterial infection. Commonly produces itching or burning upon urination.

C

Obscene, **Obscenity** A legal term denoting material which may be considered offensive by 'acceptable' community standards of decency or morality.

Oral Sex Using the mouth to stimulate the genitals of a partner. Also called oral-genital sex, it includes both cunnilingus and fellatio.

Orgasm The climax of sexual excitement, involving rhythmic muscle contractions, heightened pleasurable sensations and usually, in the male, ejaculation.

Orgasmic Capable of having an orgasm.

Ovary One of the two female sex glands that produce ova (eggs), and the sex hormones estrogen and progesterone.

Ovulation The monthly release of an ovum (egg) from the ovary. The ovum passes into one of the Fallopian Tubes where it awaits fertilization by sperm.

P

PC Muscle Pubococcygeal muscle.

Penetration The insertion of the penis or other object into the vagina or anus for sexual purposes.

Penile Of, or relating to, the penis.

Penis The erectile male sex organ.

Perineum In women, the area between the vagina and the anus. In men, the area between the scrotum and the anus.

Petting Caressing the breasts or genitals as an alternative to sexual intercourse or as foreplay.

Phallus Penis, usually in an erect state.

Premature Ejaculation A sexual dysfunction in which a man ejaculates before, or immediately after, inserting his penis into his partner's vagina.

Prostate Gland The muscular gland surrounding the male urethra. It seals off the exit from the bladder to prevent urine escaping while the penis is erect, and produces seminal fluid. Contractions of its muscles, and others around it, pump the semen through the urethra and out of the penis during ejaculation.

Pubic Hair The hair around the genitals.

R

Rectum, Rectal The lower end of the large intestine, which ends at the anus.

Refractory Period The period of time, after ejaculation in men, during which further erection or orgasm is not possible.

Rimming The oral stimulation of the anus. (See medical precaution on page 91.)

Sadism A form of sexual behavior in which a person derives sexual pleasure from inflicting pain on another person.

Scrotum The pouch of loose, wrinkled skin that contains a man's testicles.

Seduce To persuade someone to cooperate, usually in sexual intercourse.

Semen The mixture of sperm and seminal fluid ejaculated from a man's penis during orgasm.

Seminal Fluid One of the main contents of semen; produced mainly by the prostate gland.

Sex Organs The internal and external organs that differentiate men from women, including the genitals and sex glands.

Sexually Transmitted Disease (STD) A disease passed from one person to another by sexual activity. Includes bacterial and viral diseases, parasites, and fungal infections. An older term is 'venereal disease' (VD). For current and accurate information on STDs, please visit http://www.cdc.gov.

Sixty-Nine Slang term for simultaneous oral sex. The positions adopted, when viewed from the side, resemble the number 69.

Skene's Glands Two small glands located along the upper wall of the vagina opening into the urethra which produce lubrication.

Sodomy Anal intercourse.

Sperm The male reproductive cell. Its purpose is to fertilize the ovum of a woman and thus initiate pregnancy. Millions of sperm are produced in the testicles and mixed with seminal fluid for ejaculation from the penis.

Sphincter(s) A ring-like muscle, normally constricted. One example is the anus.

Squeeze Technique A method of addressing premature ejaculation in which a man's partner squeezes the head of the penis just before he reaches the point of climax.

Stop-Start Technique A method by which a man can teach himself to avoid climaxing prematurely by temporarily stopping all stimulation just prior to the moment of his ejaculation.

Straight An informal term for heterosexual.

Syphilis A sexually transmitted disease caused by a bacterium.

Т

Taboo A strong social prohibition relating to any area of human activity, including sexual activities and relationships.

Testicle(s) The two male sex glands located in the scrotum that produce sex hormones and sperm. Also called testes (singular: testis).

U

Ureter The duct by which urine passes from the kidney to the bladder.

Urethra The tube through which urine is passed from the bladder. In men, the urethra is also the channel through which semen is ejaculated.

Uterus The womb, the organ of a woman in which the fertilized ovum is deposited, and where it develops into a baby.

V

Vagina The soft, short passage that leads from a woman's vulva to her cervix, and into which the penis is inserted during sexual intercourse.

Varicoceles Enlarged or damaged veins leading to the testicles or vas deferens, a major cause of male infertility.

Vas Deferens The ducts between the testes and the urethra that sperm pass through.

Virgin, Virginal Any person, male or female, who has not had sexual intercourse.

Voyeur, Voyeurism A form of sexual behavior in which a person gets sexual pleasure from watching the sexual activities of others, or even from watching others getting undressed.

Vulva The collective external sex organs of a woman.

W

Wasserman Test A blood test for Syphilis.

Western Blot A standard blood test for the HIV antibodies.

X

X-Rated A rating indicating a movie contains material unsuitable for minors, either of a violent or sexual nature.

V

Yeast Infection A common vaginal infection caused by a yeast-like fungus.